IMAGES
of America

MANCHESTER
THE MILLS AND THE
IMMIGRANT EXPERIENCE

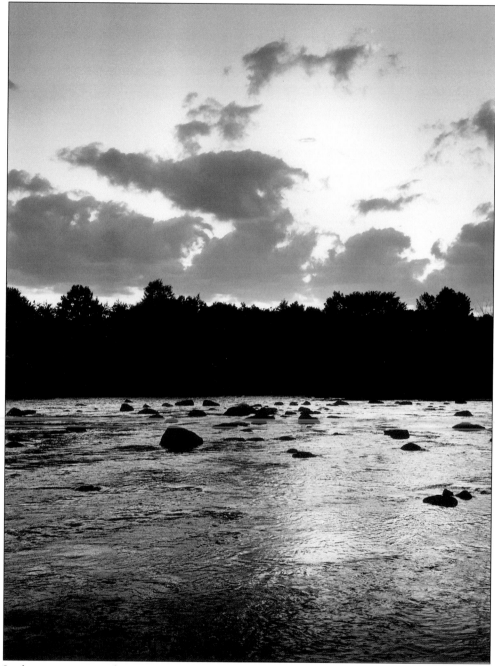

Looking west across the Merrimack River in Manchester on a summer evening. Photograph by the author, 1985.

IMAGES
of America

MANCHESTER
THE MILLS AND THE
IMMIGRANT EXPERIENCE

Gary Samson

ARCADIA
PUBLISHING

Published by Arcadia Publishing
Charleston, South Carolina

Printed in the United States of America

Library of Congress Catalog Card Number: 00106462

For all general information contact Arcadia Publishing at:
Telephone 843-853-2070
Fax 843-853-0044
E-mail sales@arcadiapublishing.com
For customer service and orders:
Toll-Free 1-888-313-2665

Visit us on the Internet at www.arcadiapublishing.com

*This book is dedicated to
my son, Gerry, and my wife, Michelle.*

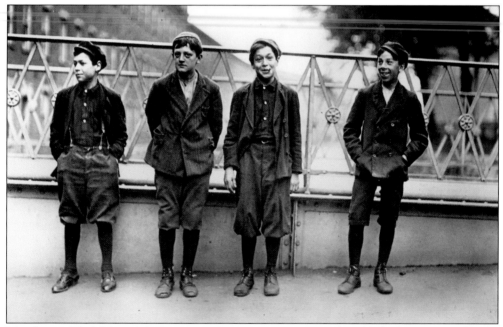

Manchester: The Mills and the Immigrant Experience was previously published in 1995 under the title *A World Within A World*. In addition, part of this work was published in 1989 in the book entitled *Merrimack Valley, New Hampshire, A Visual History*.

CONTENTS

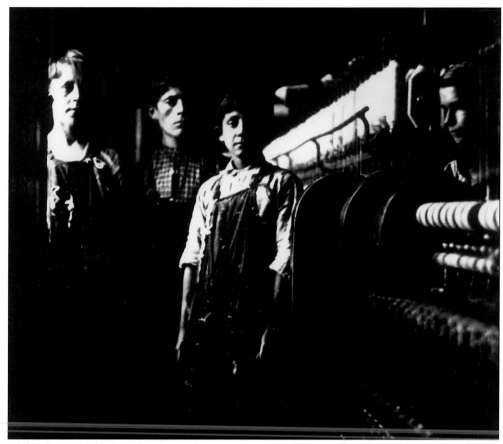

Child laborers of the Amoskeag Manufacturing Company. Photograph by Lewis Hine, 1909. (LC)

ACKNOWLEDGMENTS

The photographs that illustrate this history are largely the result of the generosity of the people of Manchester through the Manchester Visual History Research Project. Additional photographs were obtained from the Library of Congress, and the National Archives in Washington, D.C., as well as from the collections of Antoinette Bourgeois, Robert D. DeCotis, Robert B. Perreault, and the author. Access to these private holdings contributed substantially to the breadth of this book.

I would also like to thank the Manchester Historic Association for their co-sponsorship with the University of New Hampshire of the above-mentioned project, as well as the New Hampshire Historical Society, and Special Collections, Dimond Library, University of New Hampshire, for their helpful assistance.

Other individuals whose time and assistance are greatly appreciated include Alice Lacasse Olivier and Peter Randall.

I would especially like to thank Ron Scully of Arcadia Publishing, for his faith in the value of this book, and my wife, Michelle Cotnoir, for proofreading the manuscript and for her extraordinary patience and support during the preparation of this work.

PREFACE

On March 24, 1840, François Gouraud, acting as agent for Louis Jacques Mandé Daguerre's recently announced discovery, gave a lecture and demonstration of the new photographic method in Boston's Masonic Temple to an audience of five hundred men and women. After making a silver-plated copper sheet light sensitive by exposing it to iodine vapors, he placed it in the camera obscura and, aiming it out the hall window, recorded a view of Park Street and part of the Common below. In ten minutes, a successful mirror image of the scene was produced, to the astonishment of the crowd. Three weeks later, Samuel Bemis, a Boston dentist, purchased the camera from Gouraud, along with the preparation apparatus necessary to make daguerreotypes, the first practical photographic process. Included in the $76 acquisition were twelve plates, one of which was probably used to create the first landscape photograph in the United States, a view of Crawford Notch in New Hampshire's White Mountains.

Since 1840, photography has continued to play a significant role in the documentation of the people, places, and events that have built New Hampshire. The popularity of the daguerreotype, especially for portrait subjects in the 1840s and early 1850s, eventually gave way to wet glass plate and subsequent dry plate negative processes that made the production of multiple images and larger print sizes much easier. In Manchester, professional and amateur photographers employed a continually evolving photographic technology to record the Industrial Revolution as it shaped the city. Fortunately, enough of this fragile pictorial record has survived in public and private collections to enable us to gain a better understanding of the changes wrought by the industrialization of the region in the nineteenth and early twentieth centuries.

This photographic legacy, preserved in archives such as the Manchester Historic Association, the Manchester Public Library, and the Franco-American Center, among other local institutions, is what originally inspired me to look more closely at the city, its mills, and the people who were drawn to them. In the summer of 1968, I had the good fortune of obtaining a part-time job at the Manchester Historic Association. My responsibilities included everything from keeping the long brass handrail leading to the second floor gleaming to occasionally producing contact prints from the library's extensive collection of glass negatives in a makeshift darkroom located in the mop closet.

My passion at that time was photography, and it still is today. These photographs revealed to me a Manchester inconceivable to a seventeen-year-old who was not particularly interested in

history. Here was the gripping story of the great Amoskeag Mills and the Industrial Revolution unfolding for the first time in my own backyard. Five years later I learned that my grandmother Elise Samson, like tens of thousands of other French Canadians, came to Manchester in 1921 with her seven-year-old son Noel to work in the mills. They landed in the heart of "Little Canada" and lived on McGregor, Main, and Wayne Streets on the West Side for fifteen years. The Manchester City Directories of 1921–1935 revealed that my grandmother worked for the Amoskeag Manufacturing Company as a weaver and that my father Noel was listed as a secondhand helper in 1934. Like so many other children of French Canadian textile laborers, I sadly discovered that our culture and "mill" roots were something to be hidden and perhaps even forgotten.

Manchester's mills, the immigrant groups that were drawn to them in the pursuit of a better way of life, the hundreds of photographs that documented this experience, and my own family history motivated me to produce several documentary films for the University of New Hampshire on this theme, starting in the early 1970s. This book is a natural extension of those films and of my continuing interest in the use of photography as an easily accessible medium for teaching and sharing local history.

Using this approach, this history focuses on the period from 1860 to 1935 and tells the story of the rise and fall of Manchester's Amoskeag Manufacturing Company and of the immigrant groups whose lives were so entwined with its fortunes. Besides the French Canadians, immigrants from Ireland, Scotland, England, Greece, Germany, Sweden, Poland, and Lithuania, among others, were attracted to the region in pursuit of a life better than the one they were leaving behind.

The hard work of these people contributed significantly to the great success the textile industry experienced in the second half of the nineteenth century. Initially, the Amoskeag Manufacturing Company relied on local labor for its work force, but as increased demands were placed on the mill employees, the native labor force started to abandon the textile industry. Irish immigrants replaced the Yankee operatives for a brief period but with the construction of a railroad line between Québec and New England, the French Canadians became an attractive resource for mill agents who required more and cheaper labor. From 1850 to 1900 almost fifty-seven thousand French Canadians abandoned the poor economic and political conditions that existed in the Province of Québec and emigrated to New Hampshire.

One of those immigrants, a bilingual photographer named Ulric Bourgeois, arrived in Manchester with his wife at the turn of the century and rapidly established himself as a commercial photographer in the employment of the John B. Varrick Company. He was a remarkable artist with a camera, who pursued personal satisfaction in his work, as well as economic success so that his family might flourish. While Bourgeois was creating an important record of his French Canadian heritage and lifestyle both here and in the small Québec villages of Fulford and Valcourt d'Ely, the progressive sociologist-photographer Lewis W. Hine, born the same year as Bourgeois (1874), was documenting child labor in the Amoskeag Mills. According to Hine, "There were two things I wanted to do. I wanted to show the things that had to be corrected; I wanted to show the things that had to be appreciated." This statement expresses the philosophy which guided him throughout his life.

Both Bourgeois and Hine utilized the same format, a five-by-seven-inch view camera, to produce their significant but vastly different studies. A selection of their work is included in this photographic history of Manchester so that the world of work and the world of play for Franco-Americans can be compared.

Through Bourgeois' sensitive eyes we also learn about an English immigrant, Charles Alban Lambert, who led a solitary existence near what is now known as Crystal Lake in southern Manchester. The Hermit of Mosquito Pond, as he was commonly referred to, chose to live apart from the industrial development which his homeland had inspired. The last dozen years of Lambert's self-sufficient lifestyle are revealed through the extended photographic portrait created out of a unique collaboration between the Hermit and Ulric Bourgeois.

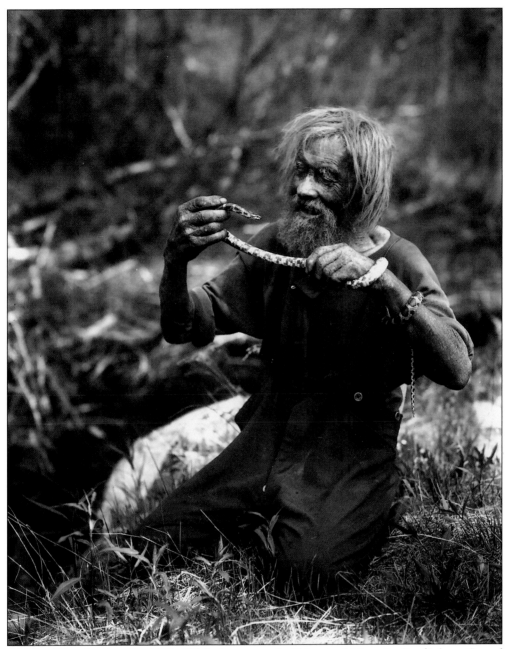

Charles Alban Lambert (c. 1823–1914), known as the "Hermit of Mosquito Pond" (now Crystal Lake), Manchester, examining a small snake, circa 1907. (AC)

In most instances, the images which comprise this volume are presented in the way that the photographers conceived them so as to enable the reader to more fully appreciate the original intention of these relatively unknown artists. This history of Manchester becomes the story of its people; powerfully illustrated and documented through the medium of photography.

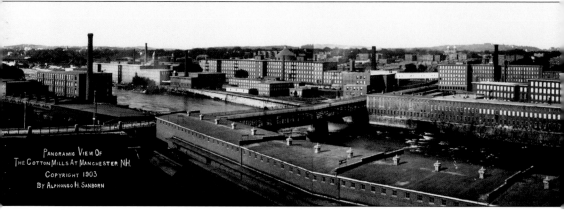

A panoramic view of the Amoskeag Manufacturing Company, Manchester, looking east.

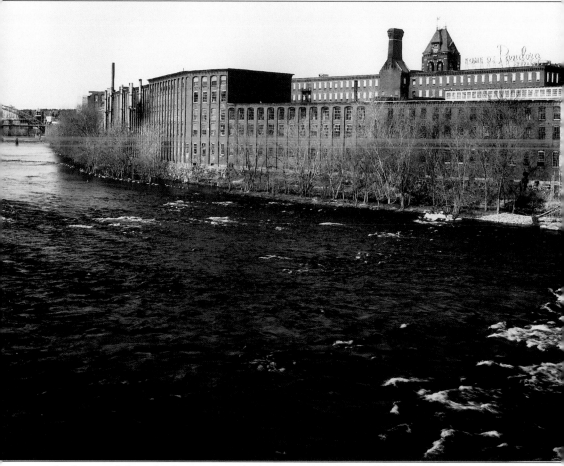

Looking north from the Granite Street bridge, some Amoskeag mill buildings have changed little since the nineteenth century. Photograph by the author, 1980.

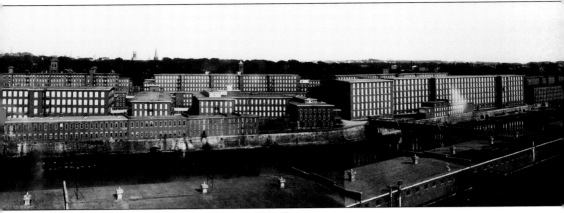

Photograph by Alphonso H. Sanborn, 1903. (MVHC)

KEY TO PHOTO CREDITS

AB	Courtesy of Antoinette Bourgeois
AC	From the Author's Collection
ALO	Courtesy of Alice Lacasse Olivier
GD	Courtesy of Gerald Durrette
HF	Courtesy of Henry Fuller
LC	Courtesy of the Library of Congress, Washington, D.C.
MCC	Courtesy of the Manchester Chamber of Commerce
MIAS	Courtesy of the Manchester Institute of Arts and Sciences
MPD	Courtesy of the Manchester Police Department
MVHC	Courtesy of the Manchester Visual History Collection
NA	Courtesy of the National Archives, Washington, D.C.
NHHS	Courtesy of the New Hampshire Historical Society
PSCNH	Courtesy of the Public Service Company of New Hampshire
RBP	Courtesy of Robert B. Perreault
RDD	Courtesy of Robert D. DeCotis
SCDL	Courtesy of Special Collections, Dimond Library, University of New Hampshire

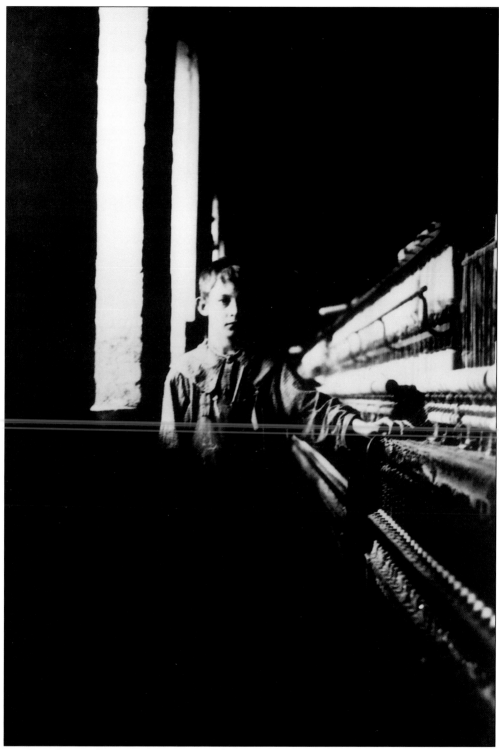

In 1909, photographer Lewis Hine captured this stark environmental portrait of a young laborer at the end of his workday in the Amoskeag Manufacturing Company. (LC)

One

MANCHESTER AND THE MERRIMACK RIVER

Throughout the history of mankind, water has served as a gathering place for the peoples of the world. The Merrimack River is no exception. The water source that eventually powered the Industrial Revolution in New Hampshire also gave sustenance to the Penacook people and their many divisions prior to their discovery by early European explorers. Unfortunately, few sites on the banks of the Merrimack have been the subject of professional archaeological studies. As a result, there is a minimal amount of information with which to reconstruct the lives of these native peoples of the Northeast.

It is known that the Penacooks and the Abenakis, for the most part, shared the territory from northeastern Massachusetts to Maine, with the Penacooks occupying most of New Hampshire. This northeastern confederacy, the most powerful east of the Mohawks, was led by Passaconaway and consisted of the Agawan, Wamesit, Nashua, Souhegan, Amoskeag, Penacook, and Winnipesaukee tribes. Like all New England Indians, these two tribes belonged to the Algonquian family. They were also divided into smaller, local groups along the Merrimack, with the Penacook tribe predominating in the area of Concord, New Hampshire.

Passaconaway spent part of each year at the Amoskeag Falls. The Amoskeag, or Nemaske, Falls derives its name from the fact that it was a great fishing center for the Indians. Namaos, meaning "a fish," and auke, "a place," well described the importance of this area to the original inhabitants, for even if their harvests and traps failed them, Namaske, the fishing place, never did. The Falls were considered the best fishing grounds between Pawtucket and Winnipesaukee.

In preparation for the fishing season, a weir was constructed consisting of a line of sturdy stakes extended across the river at 10- to 12-foot intervals. These were interwoven with birch tops and other brushwood in order to form an effective barrier. A narrow passage was left on one side of the stream so that the fish were free to pass through. Historians are relatively sure that a scientific pamphlet published in London at the beginning of the eighteenth century, however, mentions the Falls, so we do know that subsequent visitors knew of them.

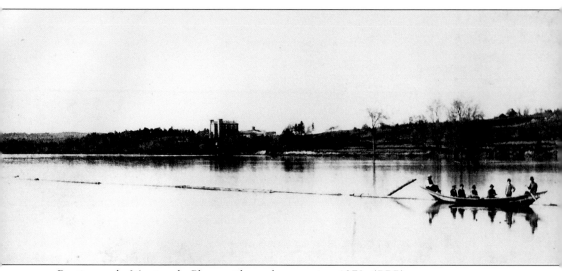

Boating on the Merrimack. Photographer unknown, circa 1870. (RBP)

The first explorations of the river were motivated by the desire to find its source. Four explorers, including Captain Simon Willard and Captain Edward Johnson, were dispatched in 1652 by the Massachusetts General Court. They discovered that the Merrimack River flowed from Lake Winnipesaukee.

The early explorers of the river valley encountered small Indian villages. According to John and Anna Lovewell, two of the first settlers in the Nashua area, approximately twenty-five inhabitants of Dunstable (as Nashua was then known) were massacred by Indians between 1673 and 1724. In 1725, the Treaty at Casco Bay, Maine, finally settled these violent conflicts between the Native Americans and the European settlers. The battle leading to this treaty was immortalized in folk song and in the following poem by Henry Wadsworth Longfellow:

LOVEWELLS FIGHT

Cold, cold is the north wind and rude is the blast
That sweeps like a hurricane loudly and fast,
As it moans through the tall waving pines lone and drear,
Sighs a requiem sad o'er the warrior's bier.

The war-whoop is still, and the savage's yell
Has sunk into silence along the wild dell;
The din of the battle, the tumult, is o'er,
And the war-clarion's voice is now heard no more.

—Henry Wadsworth Longfellow

As the towns along the Merrimack River grew and prospered, the uses of the waterway increased. Fishing continued to play an important part in river life. In addition, the river was used to transport both passengers and commercial goods. Ferries operated across the river to Hudson and Litchfield from 1729 until bridges were constructed. Pleasure boats and freight barges were also part of the river traffic.

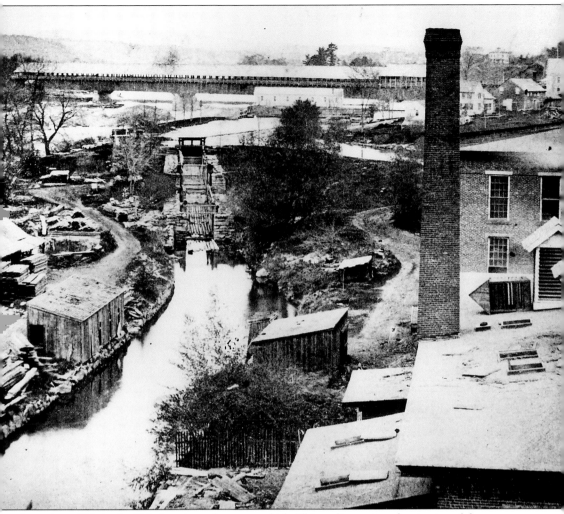

A portion of Blodget's old lock and canal system, which fell into disuse upon the opening of the steam railroad. In June 1855, the state legislature granted the Amoskeag Company permission to discontinue operation of the locks. Photograph by A.D. Stark, circa 1875. (RDD)

The importance of the Merrimack as a primary highway was increased by the building of the Middlesex Canal in Massachusetts, which received its charter in 1793 and was completed on December 31, 1803. The completion of Blodget's Canal in 1807 permitted navigation from Concord, New Hampshire, to Boston, Massachusetts, a distance of 80 miles. The barges which navigated the canal on a regular basis carried a varied cargo. On the downriver trip, a barge might contain granite being carried from Concord to Quincy Market, bricks for diverse construction sites, or lumber and other shipbuilding supplies; on the return trip upriver, English goods, groceries, fish, salt, and lime were often among the products transported.

The barges were operated by the Merrimack Boating Company which was based in Boston. It had been founded for the specific purpose of transporting freight between Concord and Boston, making stops at various points along the way. The company began its operations in October 1814 and had established a regular schedule of trips by the following June. Weather and ice conditions usually dictated a work stoppage between December and April.

A round-trip on a Merrimack Boating Company barge took nine days—five days upriver and four days downriver. Freight rates between Boston and Concord in 1815 were $13 per ton going north and $8 going south. Crew members were hired in Concord at a salary of between $16 and $26 a month. A large proportion of these boatmen were from Manchester and Litchfield. Local men were superior boatmen because of their experience of fishing at the Amoskeag Falls and rafting lumber down the river.

Thirty years of uninterrupted and successful boating followed on the Merrimack. The Merrimack Boating Company was succeeded by the Boston and Concord Boating Company in 1823. It is believed that around this time up to twenty boats were in operation on the river. These flat-bottomed barges, built to meet the particular requirements of river navigation, were from 45 to 75 feet in length, and about 9 feet in width at the middle. The oak steering oar usually measured approximately 20 feet and was secured in the middle to a pivot on the stern cross timber.

Two strong bowmen propelled the boat against the current with pike poles which were 15 feet long and 2 inches in diameter. They were assisted by the skipper in the stern when his attention was not occupied in steering the awkward craft. The barge was also equipped with a square sail which could be raised to assist the bowmen between canals when a favorable wind was blowing.

Cargo was piled along the middle of the vessel, allowing the crew to walk along the edges of the barge. The bowman stood on either side of the bow facing the stern and thrust the pole down beside the boat in a slanting direction until it struck bottom. Placing his shoulder against the top of the pole with his feet braced against the cross timbers in the bottom of the boat, he pushed the boat forward. As the craft moved, he stepped along the bottom of the boat until the movement of the boat had brought the mast board to him. He then turned around and returned to the bow, trailing the pole in the water, ready to begin the process again. Horses were required to tow the boats on narrow canals.

In 1839, noted American author Henry David Thoreau, at the age of twenty-two, set out with his brother John on a boating and walking journey into New Hampshire. His excursion notes provided the backbone to his essay, "A Week on the Concord and Merrimack Rivers," which includes the following observations of Manchester and the Merrimack River:

"These are now the Amoskeag Falls, removed a mile down stream. But we did not tarry to examine them minutely, making haste to get past the village here collected, and out of hearing of the hammer which was laying the foundation of another Lowell on the banks. At the time of our voyage Manchester was a village of about two thousand inhabitants, where we landed for a moment to get some cool water, and where an inhabitant told us that he was accustomed to go across the river into Goffstown for his water. But now, as I have been told, and indeed have witnessed, it contains fourteen thousand inhabitants. From a hill on the road between Goffstown and Hooksett, four miles distant, I have seen a thunder shower pass over, and the sun break out and shine on a city there, where I had landed nine years before in the fields; and there was waving the flag of its museum, where 'the only perfect skeleton of a Greenland or river whale in the United States' was to be seen, and I also read in its directory of a Manchester Athenaeum and Gallery of the Fine Arts.

Since our voyage the railroad on the bank has been extended, and now there is but little boating on the Merrimack. All kinds of produce were formerly conveyed by water, but now nothing is carried up the stream, and almost wood and bricks alone are carried down, and these are also carried on the railroad. The locks are fast wearing out, and soon will be impassable, since the tolls will not pay for the expense of repairing them, and so in a few years there will be an end of boating on this river."

In 1844 the Boston and Concord Boating Company ceased operations. The development of overland highways, coupled with the growing efficiency of rail transportation, spelled the

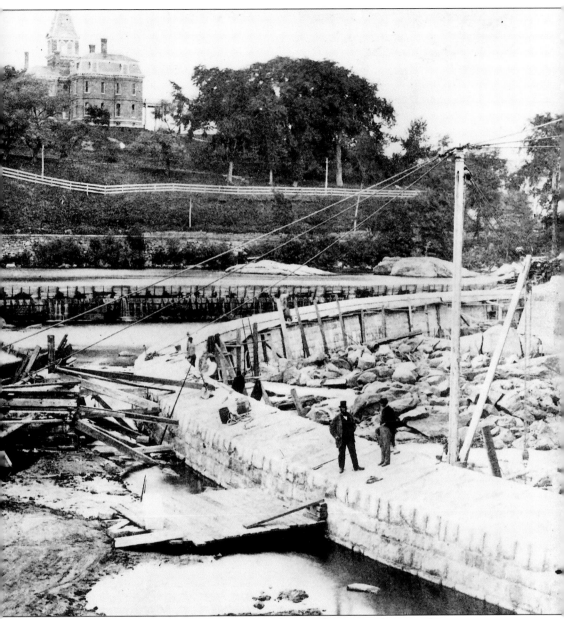

Under the direction of Ezekiel A. Straw, agent for the Amoskeag Manufacturing Company, a new curved dam 631 feet long was built to more efficiently harness the Merrimack's potential for hydropower at a cost of $60,000. The brick Victorian residence on the hill is that of former Governor Frederick Smyth (1865–1867). Photograph by A.D. Stark, 1871. (MVHC)

end of the Merrimack River as a highway. The river's importance to cities such as Nashua and Manchester was undiminished, however, as industrialists began to harness its power to fuel industrial development in the Merrimack Valley: the Industrial Revolution had arrived in Manchester, and was to change it irrevocably.

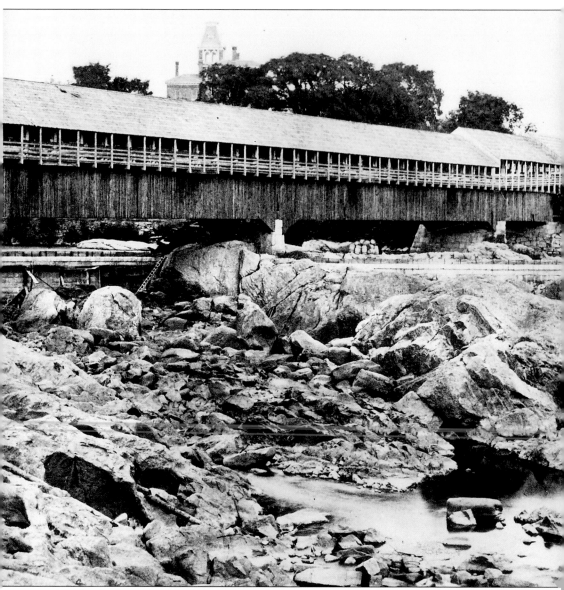

The first bridge at the Amoskeag Falls was built in 1842 and was carried away by a freshet in 1853. The wooden span pictured here was rebuilt in 1854. It collapsed into the river in 1920. Photograph by C.K. Burns, circa 1880. (MVHC)

The oldest and largest city in New Hampshire was first settled in 1722 by John Goffe Jr., Edward Lingfield, and Benjamin Kidder. These colonists from Massachusetts established the first European settlement in the Manchester area near the mouth of Cohas Brook. The next group of permanent settlers included Archibald Stark, John McNeil, and John Riddell. These families came to Derryfield, as the new town was eventually named, from Londonderry, New Hampshire, and established homes on the east bank of the river near the Amoskeag Falls.

Derryfield was officially incorporated on September 3, 1751, by King George II. When the Revolution came, the small town contributed thirty-four of its thirty-six available men to the

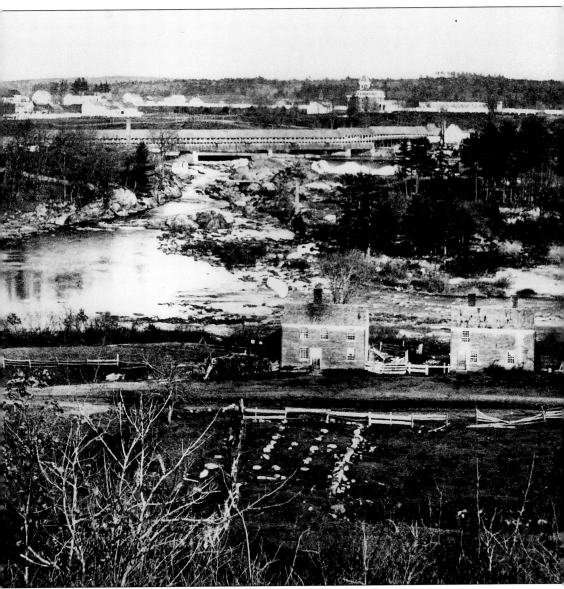

A view from West Manchester looking toward the rapids. The old road from Boston to Concord appears in the foreground. Photograph by A.D. Stark, circa 1880. (NHHS)

War of Independence. One of them, John Stark, passed into the annals of history as one of the most well-known generals of that conflict. The Derryfield contingent fought at the Battle of Bunker Hill as well as at other decisive Revolutionary War skirmishes. During the period following the War of Independence, Derryfield continued to grow steadily, as more families began farming along the banks of the Merrimack.

The principal means of transportation of heavy goods at this time was the Merrimack River, which was interrupted by the Amoskeag Falls in Derryfield. Samuel Blodget was an east bank resident who persisted in the notion that a canal could be built around the Falls in order to

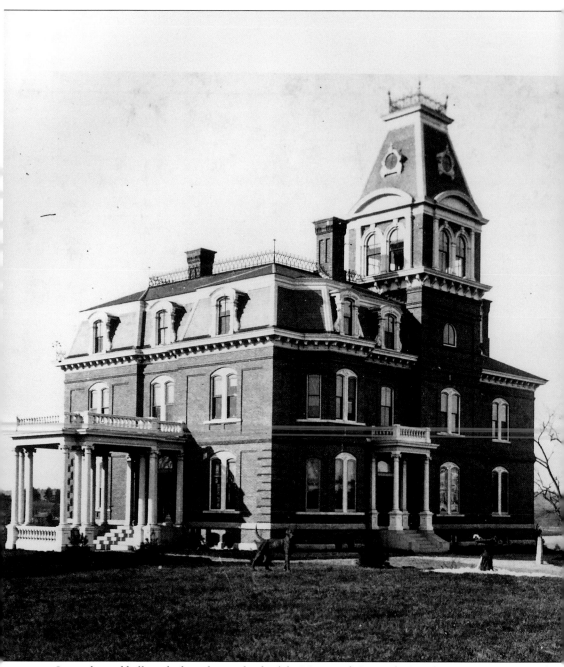

Located on a bluff overlooking the east bank of the Merrimack River, the Smyth Mansion, constructed in 1869, had a commanding view of the Amoskeag Falls. President Hayes, while a guest at former Governor Smyth's home in 1877, was the first president to use a telephone, and that instrument was only the second one in operation in Manchester. This beautiful brick structure was eventually demolished in 1969 to make way for a parking lot. Photograph by C.K. Burns, date unknown. (AC)

The late Notre Dame Bridge replaced the McGregor Bridge which collapsed in the spring flood of 1936. The pilings of the previous structure are still visible beneath the present bridge. Photograph by the author, 1976.

The First Congregational Church, erected by the Amoskeag Manufacturing Company in 1839, was located on Hanover Street. The Manchester Opera House (later the Strand Theater) would later be built on that same site. Photographer and date unknown. (MVHC)

facilitate transportation of the readily available lumber along the shores of the Merrimack. His seemingly impossible project was finally completed in 1807 and had long-range repercussions for the town.

In 1810, the town of Derryfield was renamed Manchester in deference to the views of Judge Blodget, who had visited and been extremely impressed with the thriving textile city of Manchester in England. Manchester, New Hampshire, eventually was to outstrip its namesake, becoming the largest textile center in the world by the beginning of the twentieth century. The prime mover in the development of Manchester, the Amoskeag Manufacturing Company, was incorporated in 1831. At that time, it acquired the right to all waterpower, as well as 2,500 acres of land on both riverbanks.

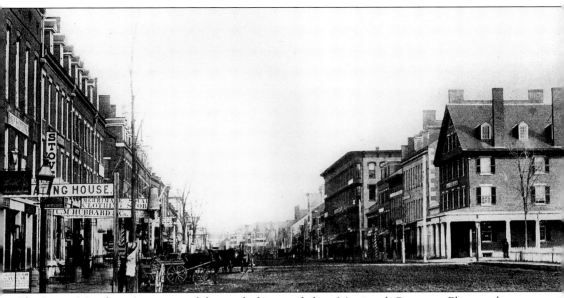

Elm Street, Manchester's commercial district, looking north from Merrimack Common. Photographer unknown, circa 1858. (MVHC)

With great respect for nineteenth-century ideals of progress and mechanical innovation, the Amoskeag Company set out to create an industrial city. Ezekiel A. Straw, the first agent of the Amoskeag Mills, was responsible for the original street plan of the city. After the streets had been mapped out, four land sales were held between October 1838 and September 1845 at which several parcels of land were sold. The first sale included 147 lots between Elm, Lowell, Union, and Hanover Streets. At this time, Elm Street was 100 feet wide. More parcels of land, this time including land between Elm, Merrimack, Union, and Park Streets (now Lake Avenue), were included in the second sale. The Amoskeag Company also donated the land for Valley Cemetery to the city in 1840 with the stipulation that the land be used for no other purpose than that of a burying ground. One of the aforementioned land sales included one to the town of Manchester. The lot, which is occupied today by City Hall, was purchased in 1841 and cost the town $2,400. Approximately 20 acres were donated to the town by the Amoskeag Company for the creation of public parks. The Company even erected the First Congregational Church on Hanover Street in 1839.

Three years later, the Concord Railroad established a line through Manchester which later became part of the Boston and Maine conglomerate. The new route would bring the raw materials required by the developing Amoskeag Mills and others, and ship away the finished product to the marketplace. In 1848, the Amoskeag Company began the manufacture of steam locomotives, selling the second engine, a 24-ton passenger locomotive named the General John Stark, to the Concord Railroad in 1849.

In 1846, Manchester became the first community to request a charter for incorporation as a city from the state legislature. At that time, Manchester had a population of more than 10,125 inhabitants. The first mayor of Manchester, Hiram Brown, a Whig, was elected on a second ballot on September 1 of that same year. At that time, three corporations, the Amoskeag, Stark, and Manchester, were producing cotton and woolen goods.

The year 1885 was the turning point for the Amoskeag Manufacturing Company, and by extension, for the city as well. Serious talk of the business leaving the Northeast to head south was stemmed with the construction of the Jefferson Mill. Without the addition of this facility,

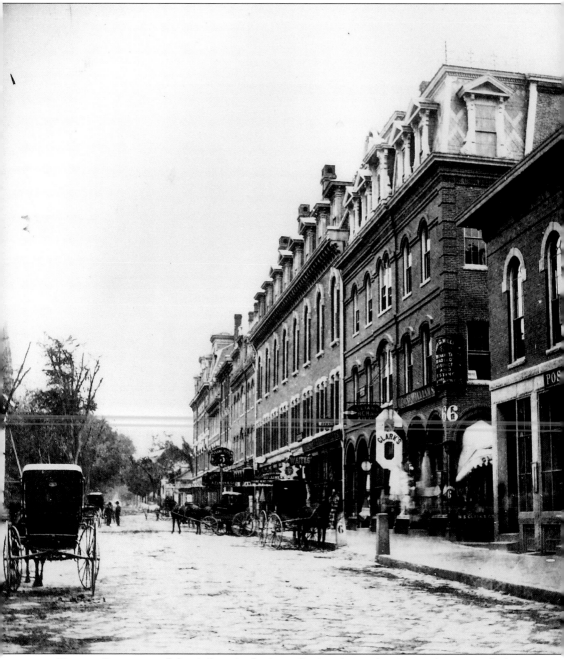

Hanover Street, one of the city's major business districts during the nineteenth century, looking east from Elm Street. Photograph by C.K. Burns, circa 1880. (AC)

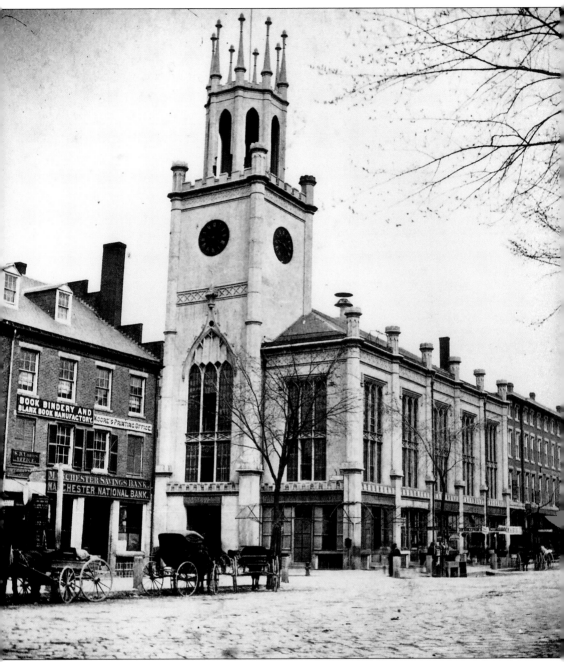

City Hall, located on the west side of Elm Street, is a focal point for traffic heading west on Hanover Street. The building was completed in 1845 and originally housed the school committee, town engineers, and the city marshall, as well as the mayor's office. The city prison was located in the southwest corner of the basement. Photograph by C.K. Burns, circa 1895. (AC)

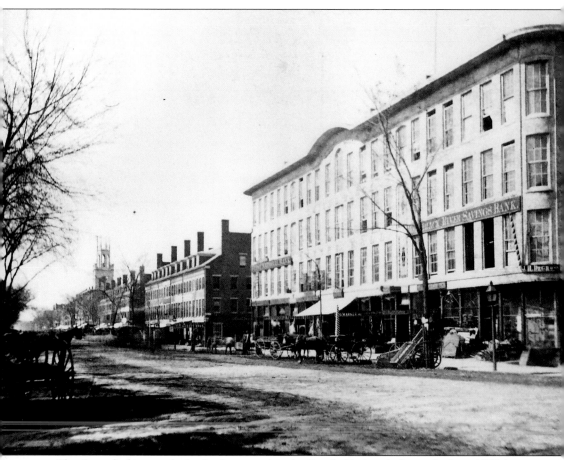

Elm Street looking south. In the foreground is the Smyth Block, which was built in 1853 by sitting mayor Frederick Smyth. The structure served as one of Manchester's prominent business buildings for decades. Its theater, known as Smyth's Hall, was the sight of a campaign speech by Abraham Lincoln on March 1, 1860. The building was razed in 1970 for the construction of the present Hampshire Plaza complex. Photographer unknown, circa 1880. (AC)

it is likely that the Company would not have grown to the gargantuan proportions it assumed in the second decade of the twentieth century. Herman F. Straw, son of the first mill agent, guided the cotton mill to unprecedented success, avoiding the labor troubles that plagued other textile manufacturers.

Manchester's 50th anniversary, celebrated in 1896, reflected the unrestrained optimism brought about by the prosperous times. The week-long event was marked by numerous parades along Elm Street, whose buildings were swathed in bunting. As the end of the nineteenth century became the beginning of the twentieth, Manchester's population grew to fifty-seven thousand inhabitants. Forty daily passenger trains served its inhabitants.

In 1919, when profits had escalated to nearly $8,000,000, it was impossible to predict that labor strife would permanently cripple the Amoskeag Company just three years later. During this time the economic survival of the city seemed inexorably linked to the Company's prosperity. Disaster hit the city in the form of a nine-month strike against the Amoskeag Company in 1922. Work resumed in November of that year; it would be another thirteen years

before the Amoskeag would finally close its doors, but the critical blow had been struck. With the strike of 1933, which was so bitter that military protection was required for the Amoskeag property, a series of shutdowns began which presaged the final closing in 1935. In March 1935, employment peaked at 11,014 people; by September 15 of that year less than 1,000 workers were employed, marking the virtual closure of the mills.

On the heels of the Mills' closing came the flood of 1936. Grace Holbrook Blood, in her book *Manchester on the Merrimack*, gives the following graphic description of the flood:

"Breaking all bounds and precedents, it developed into a raging torrent, rioting through the empty mill yards, flooding basements, first floors, even second story tiers; burying machinery under tons of mud and silt, robbing hundreds of their homes, creating havoc with the water supply, the lighting and telephone systems, and producing throughout the community a major emergency. All industry was at a standstill, all normal activities interrupted . . . To mills and municipalities alike, the flood dealt a staggering blow."

The combination of the closure of the Mills and the flood was devastating for Manchester. The city created by the Amoskeag Company to house its work force and grow with it lost its raison d'être, and the way forward was in no way as clear-cut as it appeared in the early days of development. But the city prevailed. In the fall of 1936, Amoskeag Industries of Manchester was formed. The newly formed corporation bought the physical assets of the Amoskeag Manufacturing Company with the help and support of Manchester's businessmen. This corporation attracted diverse industries to the mill sites with the result that, during the 1940s, 120 companies provided employment for 12,500 Manchester inhabitants.

After many changes today Manchester maintains its position as New Hampshire's largest and most prosperous city.

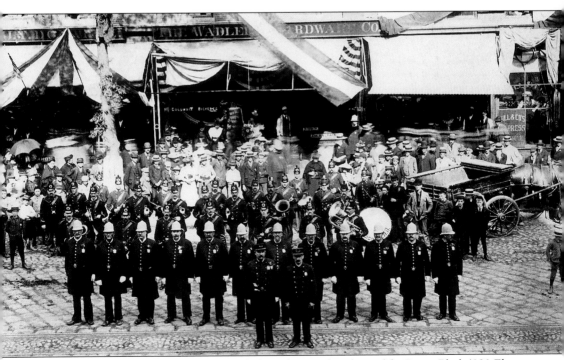

Members of Manchester's police force pose briefly for a photograph in front of the Patten Block (930 Elm Street), during a parade along Elm Street. Photograph by J.G. Ellinwood, circa 1880. (MVHC)

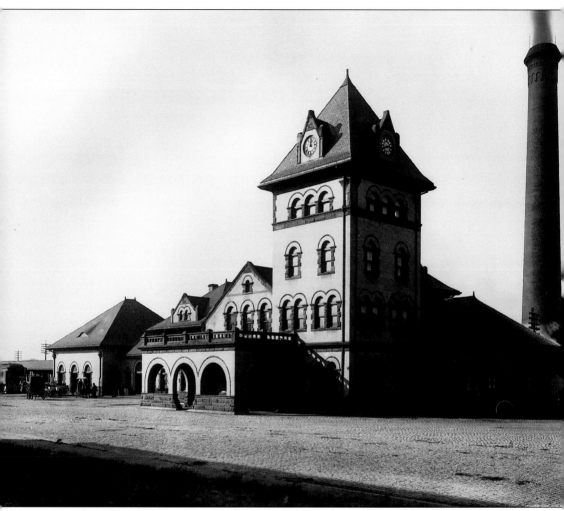

Union Station, constructed in 1898 by the Boston and Maine Railroad, was the first stop for visitors traveling to Manchester by train. The passenger station stood at the foot of Depot Street near the intersection of Canal and Granite Streets. During the 1950s, passenger train service in northern New England became virtually obsolete, and so the elegant yellow-brick and brown-stone structure was demolished in the autumn of 1962. Photograph by the Detroit Publishing Co., circa 1905. (LC)

The Weston Observatory was erected at a cost of $5,000 in the years 1896–1897 at the bequest of former Governor James A. Weston (1871–1872 and 1874–1875). Located at the top of Oak Hill overlooking Derryfield Park, the granite structure stands 66 feet high. Looking west, a dramatic panoramic view of the city can be seen from the observatory's platform. Photograph by the Detroit Publishing Co., circa 1898. (LC)

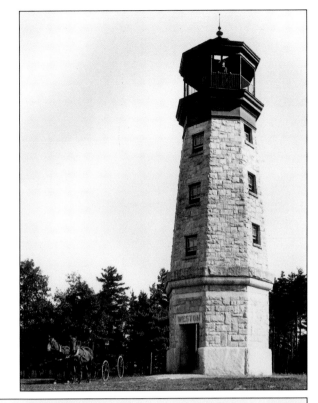

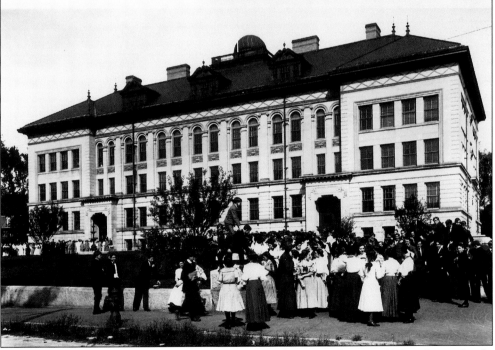

The Classical Building, Central High School, was dedicated on September 10, 1897, and praised as the finest high school building in New England. Photograph by the Detroit Publishing Co., 1908. (LC)

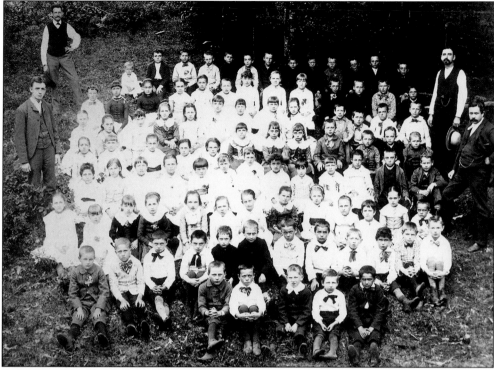

A German School picnic at Koëhler's Grove. Photographer unknown, circa 1892. (MVHC)

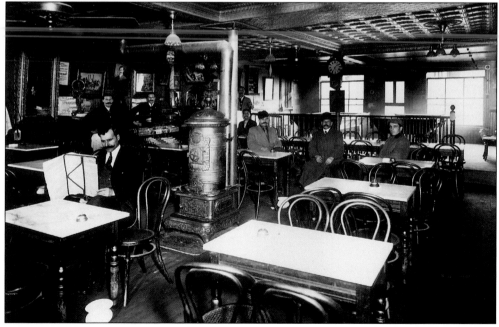

A Greek coffeehouse. The first Greeks settled in the city in 1890. In 1905, the Greek population was estimated at five hundred, a sufficient number to support a Greek Orthodox Church. By 1910, the census reported 1,330 foreign-born Greeks in Manchester. Photographer unknown, circa 1910. (MVHC)

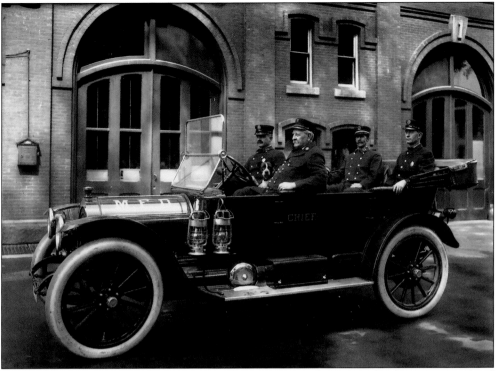

The fire chief's car, parked in front of the Vine Street station. By 1927, the fire department employed 118 men and was completely motorized. Photograph by Ulric Bourgeois, circa 1911. (AC)

President William Howard Taft, campaigning for reelection on the Republican ticket, arrives at Union Station. Photographer unknown, 1912. (MVHC)

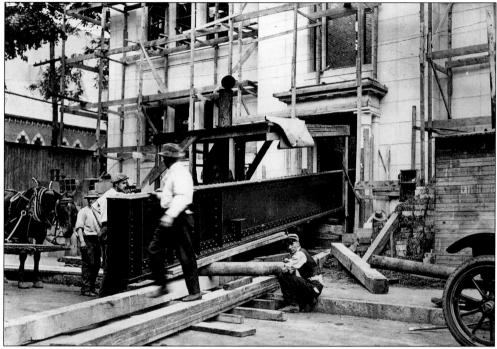

The Manchester Institute of Arts and Sciences under construction in 1916. The heavy steel girder that will provide support for the gallery is being slid through the Pine Street entrance. Today, the school is called the New Hampshire Institute of Art. Photographer unknown. (MIAS)

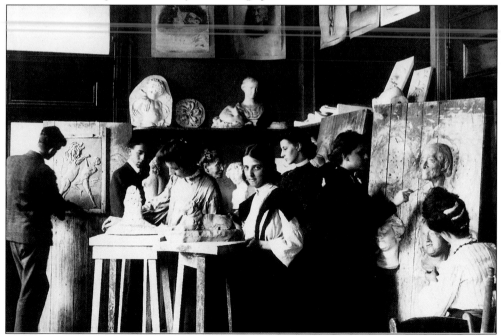

The Manchester Institute of Arts and Sciences became the center of culture and art education in the community, offering courses in fine arts, music, literature, home economics, natural science, and social science. It is now the New Hampshire Institute of Art. Photographer unknown, circa 1918. (MIAS)

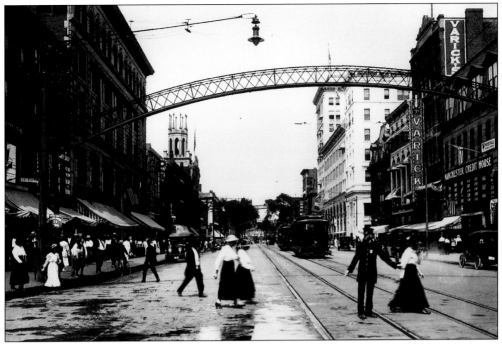

Elm Street, looking north from the intersection with Merrimack Street circa 1920. The first electric trolley car service on Elm Street was begun on June 8, 1895. Photographer unknown. (MVHC)

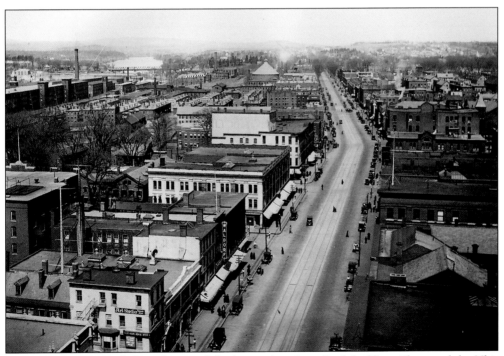

Elm Street looking north from the top of the former Amoskeag Bank building. Photograph by Ulric Bourgeois, circa 1927. (MVHC)

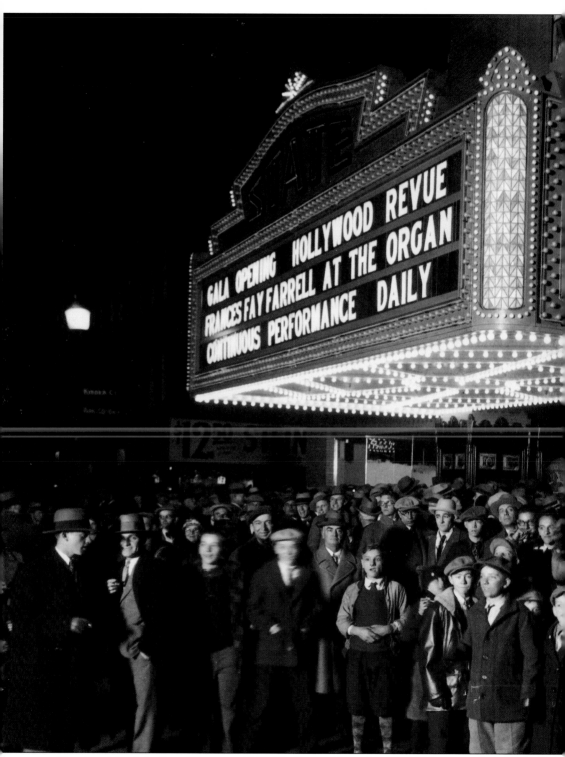

Opening night of the State Theater at 1118 Elm Street, November 27, 1929. The auditorium could seat 2,190 people and required 14 ushers for operation. A chandelier, measuring 10 seats across,

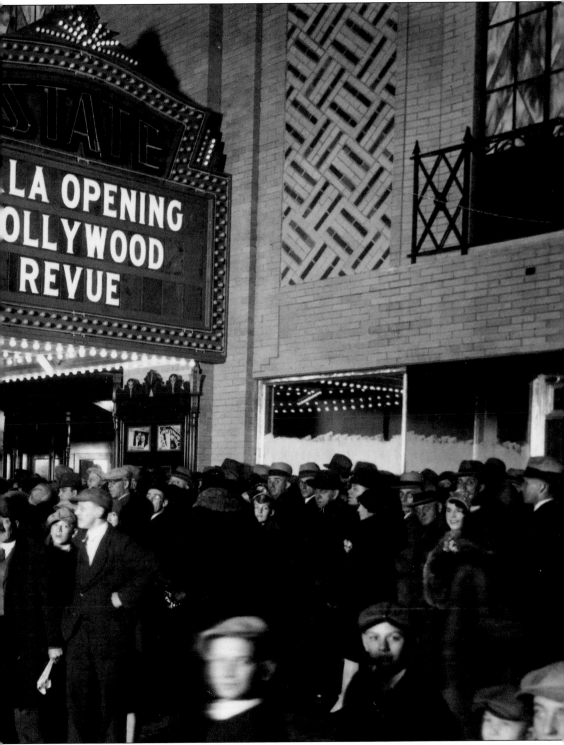

was illuminated by several thousand red, white, and blue bulbs. The theater was demolished in 1978. Photographer unknown. (MVHC)

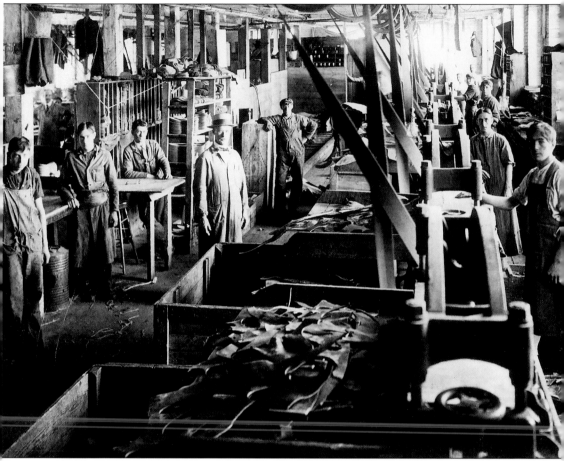

Workers pause for a photograph at the Hoyt Shoe Company. Shoe manufacturing was an important industry in Manchester during this period and provided an alternative work environment to the textile mills. Photographer unknown, 1908. (MVHC)

Two

THE AMOSKEAG MANUFACTURING COMPANY

In Manchester, the Merrimack River still flows through the once great Amoskeag Manufacturing complex. The entire spectrum of nineteenth-century industrial technology and architecture and the resulting social effects were acted out here in the largest textile mill yard in the world. Although the Amoskeag complex and the city that was built around it were a unique example of community planning, the tremendous growth ended in complete collapse on Christmas Eve of 1935. Today, only a partial skeleton remains of the once-unified brick mass that followed the bend in the river.

Shortly after the War for Independence, Samuel Blodget of Derryfield crossed the Atlantic to visit Manchester, England. What he saw in that teeming and ever-expanding industrial city filled him with dreams of a future, dreams that could be fulfilled here in his homeland. Returning to America, Blodget settled near the furious rapids and 50-foot descent of the Amoskeag Falls on the Merrimack River. Transportation in this relatively undeveloped area posed a serious threat to Samuel Blodget's ambitious enterprise. In order to sell his goods, which included lumber, fur, and linen, a fast and inexpensive route had to be found. Blodget saw that a canal around the Amoskeag Falls was the secret to opening the Merrimack River as a new route to move his merchandise; in 1807, after fourteen years of work and many obstacles, eighty-three-year-old Samuel Blodget rode triumphantly down his completed creation.

With the obstacle of the Falls overcome, the banks of the Merrimack rapidly became a site for trade, including the operation of cotton-spinning mills. The swift-flowing water of the Merrimack River provided the power to process the raw cotton and to build the kind of manufacturing empire Blodget envisioned.

A petition was drawn up by the Boston Associates asking the state legislature for "power and protection" to raise $1,000,000. The funds obtained were to be used by the Boston-based capitalists to develop the enterprise they had launched on the Merrimack.

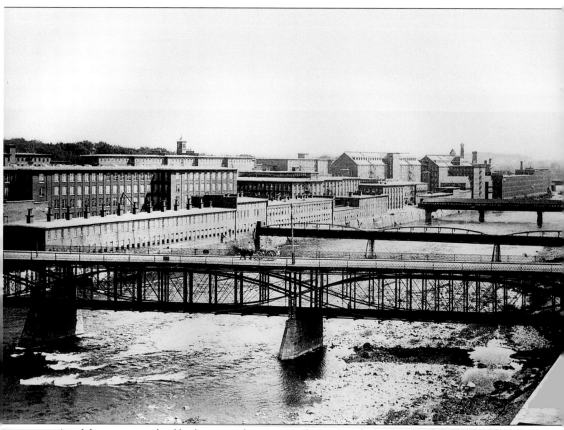

An elaborate network of bridges over the Merrimack River and passageways between buildings linked Amoskeag's sprawling mill complex. Art Work of Manchester, W.H. Parish, publisher; photographer unknown, circa 1892. (RBP)

The Amoskeag Manufacturing Company was incorporated on July 1, 1831, with an authorized capital of $1,000,000. The partners conveyed the property to the new corporation for $100,000. Lyman Tiffany was elected president, Ira Gay, clerk, and Oliver Dean, treasurer and agent. Lyman Tiffany, Willard Sayles, and Ira Gay were made directors. The corporation acquired title to lands on both sides of the river, but mostly on the east side, where the best sites for mills and advantages for extending canals were found. The properties of the Bow Canal Company, the Amoskeag Locks and Canal Company, the Isle of Hooksett Canal Company, and the Union Locks Canal Company were purchased and merged with that of the Amoskeag Manufacturing Company before 1837. The upper canal was built during 1836–37, and the lower canal in 1838–39. William Amory became treasurer in 1837 and held the office until his resignation in 1876. To meet the demand for machinery for their own mills and for those they erected for others, the Amoskeag Company built a machine shop in 1840. In 1842, a foundry was erected, and in 1848, both of these were replaced by new and larger ones.

The enterprise had become a palpable reality: by 1838 the Amoskeag designers had prepared plans for a utopian-like community on part of the 26,000 acres of land the company had acquired. This plan included six parks and specifications for churches, schools, libraries, and public buildings to be built on broad streets laid parallel to the river. A conscious policy was enforced to assure a uniformity of facade. The buildings were to be of brick or stone and slated,

and every lot, large or small, was to have only one building on it for the duration of twenty-five years from the date of sale.

Bricks made 8 miles up river in Hooksett were the basic building material used in the mills. Construction and renovation, spanning three quarters of a century, created an ever-changing, yet cohesive, environment. When land was sold to other companies for mill buildings, Amoskeag did the construction work, ensuring the uniformity and unity of the mill yard environment. Although other textile mills became part of the New England landscape, the sprawling Amoskeag complex holds the distinction of being laid out and designed by the engineering firm of one company.

By 1851, Amoskeag had secured worldwide recognition for the superior quality of its products. An important highlight of the first World's Fair held in London that year was the international textile competition. At that time Great Britain was the undisputed leader of the world's commercial textile market. The Amoskeag Company sent samples of fabrics, flannels, sheetings, tackings, and denims to England for the event. The competition was judged by a majority of Englishmen, several continental Europeans, and only one American, yet Amoskeag was awarded the first and only prize, a bronze medal.

An excerpt from the 1854 city directory of Manchester listed the following statistics in the *Amoskeag Bulletin:*

"The annual consumption of cotton is 9,000,000 lbs; employs 475 males, 2,100 females, manufactures annually 20,000,000 yards sheetings, drillings, tickings, mariner stripes, denims, and flannels. Uses 400 tons coal, 9,000 cords wood, 15,950 gals. of oil, 130 tons of starch, 25,000 lbs. indigo; 109 tenements are used as boarding houses; $520,000 paid out yearly in the mills."

In order to perfect yarn techniques, the Amoskeag Company brought experienced dyers and weavers from England and Scotland. These critical skills were so important to the growing American textile industry that United States immigration laws were altered on July 4, 1864, to accommodate the entrance of foreign experts. The Scots proved more successful at millwork than the English, and were offered an additional incentive. In the 1860s, passage from Scotland cost about $40, and the Amoskeag Company offered a "travel now, pay later" plan to these highly skilled specialists. This program marked the beginning of the Amoskeag Company's supremacy in the production of colored goods—a supremacy which lasted seventy-five years.

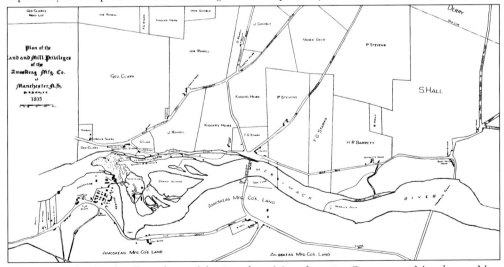

A plan of the land and mill privileges of the Amoskeag Manufacturing Company at Manchester, New Hampshire, 1835. (MVHC)

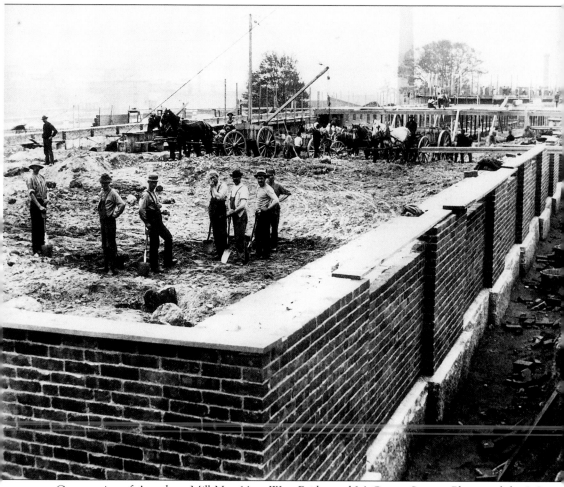

Construction of Amoskeag Mill No. 11 at West Bridge and McGregor Streets. Photograph by J.G. Ellinwood, 1889. (RBP)

The process of producing cotton textiles comprised several stages. Three different types of raw cotton were used. Sea Island, or long-staple, cotton was used for the lengthwise threads (the warp), and United States-produced medium-staple cotton was used for the crosswise threads (the weft). Depending on the type of cloth being produced, short-staple cotton from India was sometimes mixed with the medium-staple cotton. Because the Indian cotton contained harder fibers, it was used when a sturdier cloth was required.

The raw cotton arrived at the mill in matted and tangled bales. It was necessary to clean or pick the cotton before it could be made into thread. This was done by means of an opener or spreader. This machine produced a thick, fluffy sheet of fiber called a lap, which was then wound onto a large roller. In the carding process which followed, the lap was placed onto a large cylinder and combed until it became a gauze film, which was then pressed between two rolls to form what was called a sliver. Drawing frames rolled the sliver several more times in order to produce the thread that was to be used to weave the cloth. Before the thread could be used in the cloth-making process, however, it was twisted and placed on bobbins. The bobbins were mounted on spindles—360 spindles constituted a spinning machine.

The thread from the bobbins was separated into lengths, called hanks, of 840 yards. In order to determine the coarseness of the thread, it was numbered according to hanks per pound. The coarsest thread was No. 2, while the finest thread was No. 300. Once this was done, the thread for the weft was placed on bobbins to be used in the shuttle, while the thread to be used for the warp was sized and wound on beams to be used in the loom.

The presidential campaign of 1860 brought Abraham Lincoln to Manchester as the invited guest of mill agent Ezekiel Straw. The morning after the candidate's speech to an overflowing crowd, Lincoln accepted an invitation to tour the mills. Lincoln visited mills that were manufacturing cotton products. But soon, the Amoskeag Company was to shift its energies to

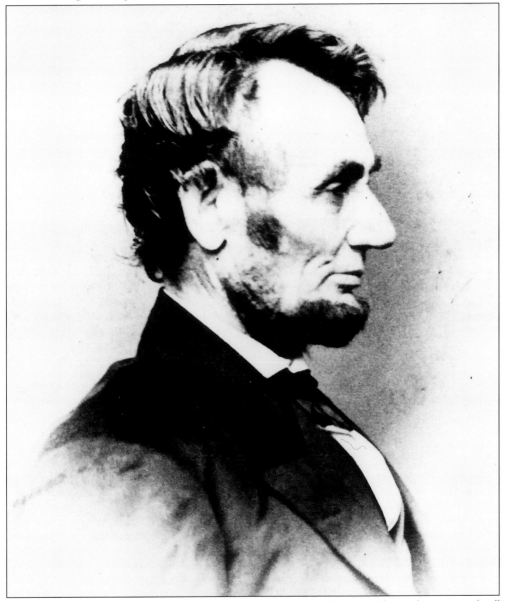

During the campaign of 1860, Abraham Lincoln visited the Amoskeag complex at the request of mill agent Ezekiel Straw. Photograph by Matthew Brady and Company, circa 1860. (SCDL)

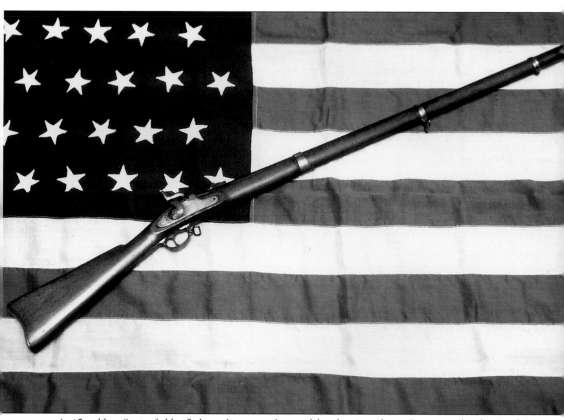

A 45-caliber Springfield rifled musket manufactured by the Amoskeag Company for the Civil War. Photograph by the author, 1975.

the production of twenty-five thousand 45-caliber Springfield rifled muskets for the Civil War. During the famous "Draft Riots" in New York City in 1863, it was rumored that an attempt was to be made to seize the daily output of arms of the Amoskeag Company. Governor Straw prepared for the emergency, should such an attack be attempted. He had a 6-pound brass field piece mounted in the yard, at the gate just west of the lower canal, and in the line of Stark Street. It was manned by some discharged members of the First New Hampshire battery, and a guard was stationed in the mill yard for a period of time. Only after the country was reunited were the mills able to obtain again the precious cotton which was their lifeblood.

In 1848, the Amoskeag machine shop and foundry were enlarged to accommodate the construction of locomotives. Between 1849 and 1859, 232 locomotives were built for use on the northern railroads. John C. Moore described the "old big shop" as it appeared in 1853:

"I was soon introduced to the locomotive department, where amid the clanking of ponderous hand tools, the thundering music of a multitude of tilt hammers, of all sorts and sizes, the rasping sound of files and the dull solidity of sound which the monster planing and punching machines gave forth, I discovered some half a dozen large locomotives in progress, besides one outside the door in process of being fired up for a testing operation. These engines were in various stages of forwardness—one nearly finished. The finished engine to which I referred was designed for a Pennsylvania railroad, was some twenty-four tons weight and was named the "Missouri." It is in all its parts, not excluding the ornamental, (the mere finishing of which was only required) one of the most splendid engines I have ever seen."

AMOSKEAG
ACHINE AND LOCOMOTIVE WORKS

An illustration from an Amoskeag promotional pamphlet. (MVHC)

In 1859, production of locomotives was discontinued, but the factory retooled for the manufacture of another kind of heavy equipment: steam-operated fire engines. Amoskeag No. 1 was the first steam fire engine to be built by the Amoskeag Manufacturing Company. Designed and built under the direct supervision of Nehemiah S. Bean, it was tested on July 4, 1859, raising steam and shooting two streams of water to the height of 203 feet in seven minutes from the time the fires were lit. It was a rotary pump engine that threw the water by centrifugal force. The pump always had to be primed, which caused some delay.

The purchase of Amoskeag No. 1 by the City of Manchester at a cost of $2,000 caused a stir in all fire department circles. The conservatives in the field held to the old hand machines and looked upon the steamer as a useless innovation. They prophesied failure and hailed the first alarm of fire as an opportunity to display the overshadowing merits of the hand tub. That first alarm called the apparatus to the vicinity of the old locomotive works, and an immense

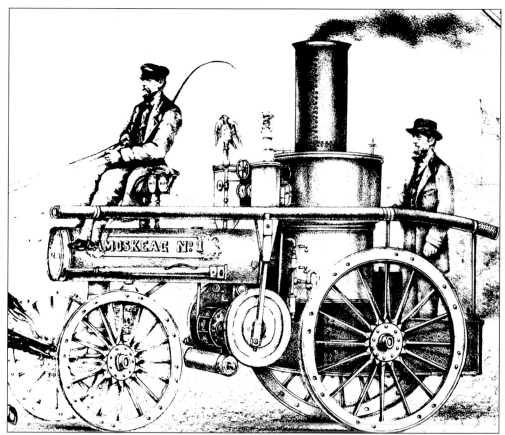

Amoskeag No. 1, the first steam fire engine built by the Amoskeag Manufacturing Company. (MVHC)

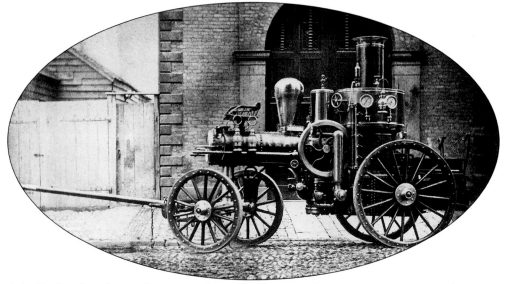

Arba Read, a first-class single engine with one double-acting plunger pump, was a steam fire engine manufactured by the Amoskeag Company. Photographer unknown, 1860. (RDD)

crowd turned out to witness the test. The rotary engine was hauled back to its quarters an easy victor and continued in service until October 1876, when it was replaced and sold to a lumber company in Canada.

In 1867, steam fire engine No. 225 was in the process of construction and, merely as an experiment, it was fitted to propel itself. As a result of that experiment, another self-propeller, No. 263, was built under the supervision of Nehemiah S. Bean, the mechanical superintendent. This engine was looked upon as a wonder, and was shown around the country. No one, however, was convinced enough of its practicality to purchase it, and so, after extended travels, it returned to Manchester where it remained in storage for five years. In November 1872, the memorable Boston fire broke out and aid was requested of Manchester. The Amoskeag Company sent down the horseless engine and it performed so well at that fire that it was purchased by the City of Boston.

By 1876, when the Company closed out this branch of its industry to the Locomotive Works, 550 engines had been constructed for customers in the United States and for export to Canada, Chile, Peru, China, Russia, Japan, France, New South Wales, and England.

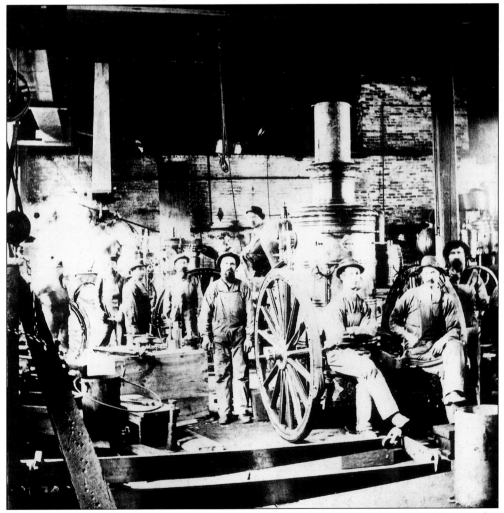

Employees pose in this interior view of the Amoskeag Steam Fire Engine Works. Photographer unknown, circa 1865. (MVHC)

Like other New England mills, the Amoskeag Company first drew upon local sources for laborers. As the mills expanded, greater numbers of workers were needed to keep pace with the worldwide demand for Amoskeag cottons. Immigrant laborers were hired to run the great machines of the Amoskeag Mills. The Irish were the first ethnic group to work in the mills. They were followed closely by French Canadians, who became the largest immigrant group in New Hampshire, and, by the turn of the century, in New England. Other ethnic groups, in smaller numbers, also began to appear in Manchester. The following brief article, printed in the February 15, 1913 edition of the *Amoskeag Bulletin*, illustrates the complexity of hiring the large number of workers required by the Amoskeag Company:

Where Help is Engaged
20,000 in 15 months
Labor Department of the Amoskeag Met Obstacles but
is now Successful

"If you were required to interview a line of applicants thirty-three miles long, giving each person ample time to make known his qualifications and special fitness for a certain position, drawing him out with intelligent, leading questions, at the same time studying his "human nature" side, weighing him in the balance, as it were, would you undertake the contract, to be completed in fifteen months?

This is the task which has been accomplished by the employment department in the first fifteen months of its existence. At least 155,000 men and women have been interviewed within that time and each has received courteous treatment. About 20,000 employees have been

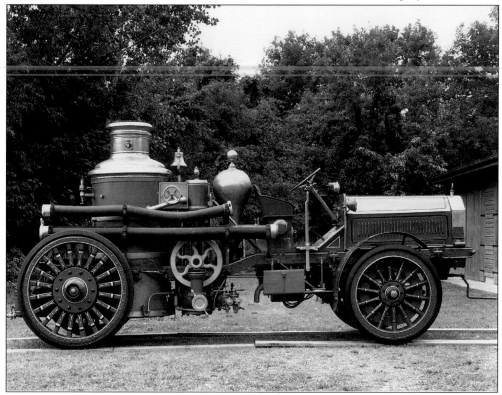

Delivered to the fire department of Hartford, Connecticut, in July 1889, No. 644, or "Jumbo," was the largest steam self-propelled fire engine ever built. Photograph by the author, 1987.

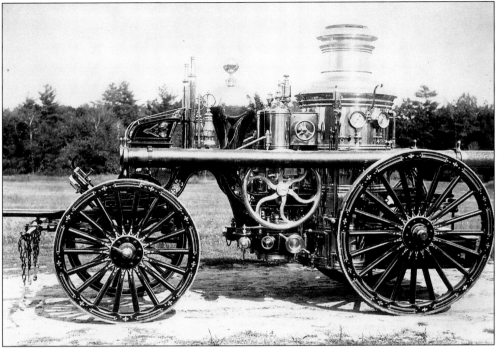

Amoskeag No. 1, manufactured by the Manchester Locomotive Works, which assumed the manufacture of Amoskeag steam fire engines after 1876. Photograph by Piper, 1877. (MVHC)

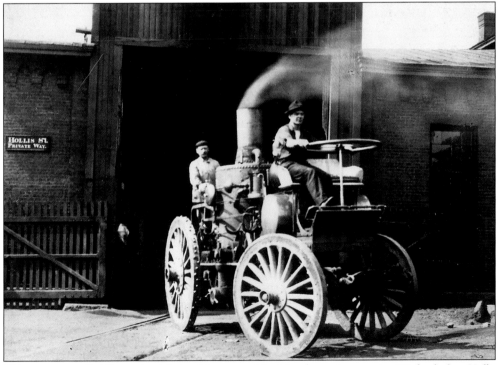

This steam-propelled fire engine is being driven out of the Manchester Locomotive Works shed on Hollis Street. Photographer and date unknown. (RDD)

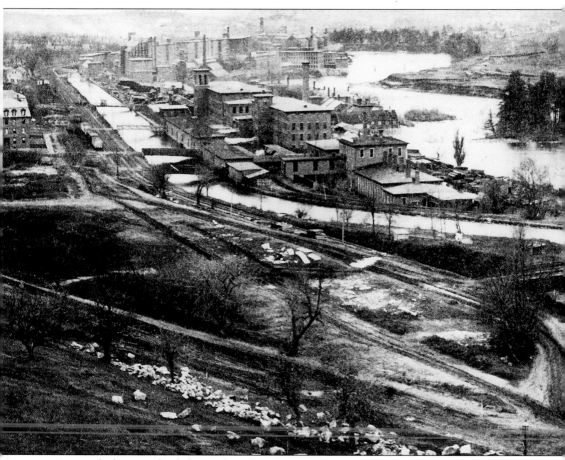

A view looking south of the north end of the Amoskeag Mills and canal system. Photograph by D. Stark, circa 1880. (MVHC)

engaged and started to work. Of this number many were "rolling stones" and their stay was of short duration. But the vast majority have proved to be steady and reliable . . .

During the week of September 7, over 700 people were hired while during the week of December 14, 1912, but 306 employees were added to the rolls, due to a corresponding falling off in the number of persons leaving. About two per cent leave the mills every week.

Ours is truly a cosmopolitan city. Of the 306 persons just referred to, we find eight per cent are Americans, thirteen per cent Irish, eight per cent Polish, eleven per cent Greek, fifty-one per cent French and the balance made up of English, German, Scotch, Swedish, Lithuanian and Russian."

Young unmarried women from rural New England comprised much of the early labor force of the textile mills. Susan Blount reported in her journal, which dated from 1828 to 1843: "Most of the girls that I was acquainted with worked in the spinning room, where there were hundreds of young girls working . . . some of them not more than 9 or 10 years old."

It is all too easy to imagine that the mills were entirely miserable places. In some ways they were, but this idea should be tempered by a realization of the opportunities they could offer. Jennie E. Hadley, a Manchester "factory girl," wrote the following letter to a local

newspaper defending the quality of life of many young women as employees of the textile mills during this period:

Manchester Corporation
Feb. 18, 1860

"Mr. Editor: – Some of our honorable Southern men have taken the liberty to fasten upon the Northern factory girl the name of slave. They pretend to say that we are under the same tyrannical oppression. That we are compelled to abide by the same rigid laws as are slaves under their control. But if in sincerity they believe that such is our lot, I hope they will pardon me if I tell them they are laboring under one of the great errors that are now becoming so prevalent in our land . . .

Not a happier band of persons exists on the face of the habitable globe than those whom they have dared to compare with the Southern slave. We are perfectly free and independent to come and go when we choose. We have plenty of money, which we can expend for clothing, give to

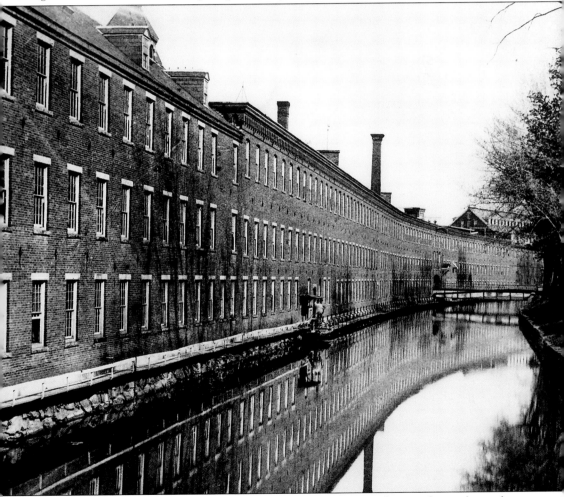

From an architectural standpoint, the Amoskeag Manufacturing Company always endeavored to render and maintain its mills and the surrounding area as attractive as possible. Art Work of Manchester, W.H. Parish, circa 1892. (RBP)

charitable purposes, or deposit in banks. To be sure, we have our regular hours to work, but is this slavery? Did our Creator place us here and endow us with faculties of mind and body to idly dream away the precious moments he intended we should improve? Surely not. . . .

We attend church and the sabbath school, read good books and papers, and write for them occasionally. Yes, Manchester's mills, as well as all others, can boast of intelligent and noble hearted sons and daughters. We have among us scholars and teachers and some have gone from our midst to other shores to enlighten the dark and benighted minds of the heathen and thus hasten the day when freedom and equality shall prevail throughout the length and breadth of our glorious land . . ."

With growth in production and expansion of the mills, the Amoskeag Company needed a larger labor force. The firm first recruited workers from other parts of New England. Later, Irish immigrants willing to work for smaller salaries displaced the mill girls. The discovery of the French Canadians as the most "industrious and docile labor group" led the Corporation to embark on a glamorous propaganda campaign designed to attract disenfranchised French Canadians.

Forty girls and boys would be sardined into an old lumber wagon. After the grueling ten-day trip to Manchester, many were greeted by an angry crowd of townspeople wielding guns

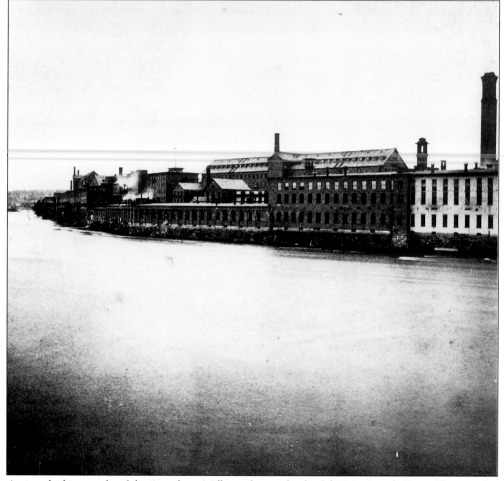

A view, looking north, of the Amoskeag Mills on the east bank of the Merrimack River. Photographer unknown, circa 1880. (RBP)

50

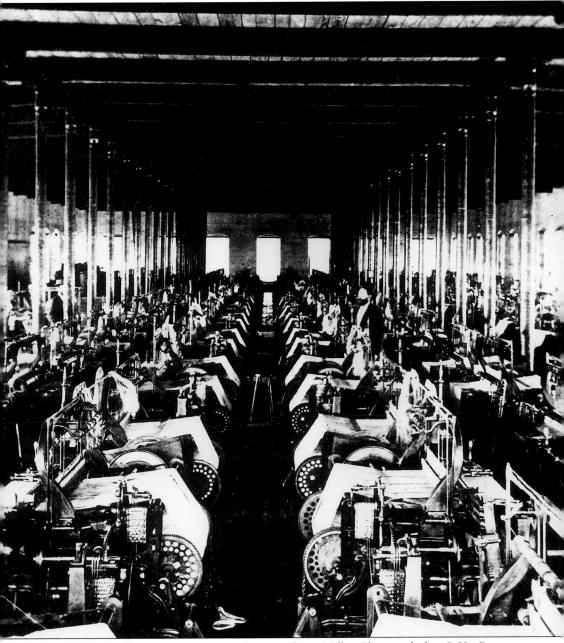

An interior view of a weave room at the Amoskeag Mills. Photograph by C.K. Burns, circa 1875. (MVHC)

and pitchforks. The Canadians were not always welcome, but they stayed. In 1879, French Canadians accounted for one tenth of Manchester's population. By 1890, only eleven years later, their numbers had increased to fifteen thousand—one third of the entire town.

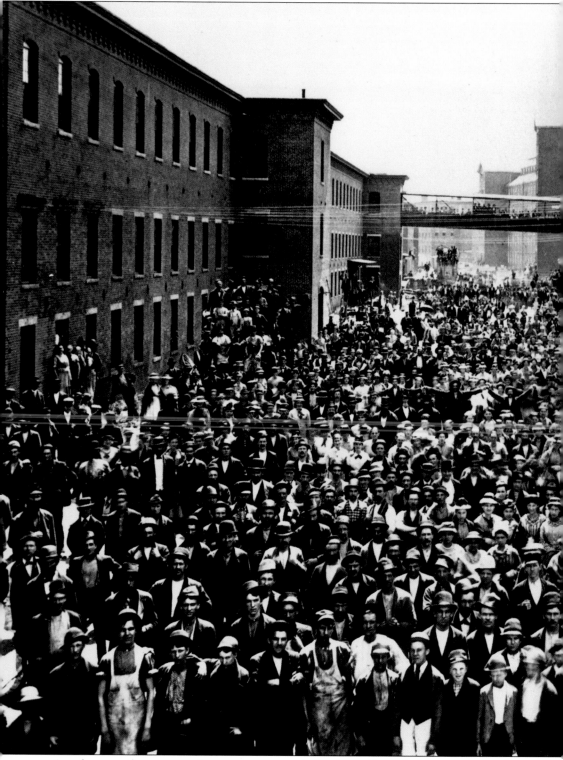

Amoskeag employees pose for a group portrait in the mill yard. Photographer unknown,

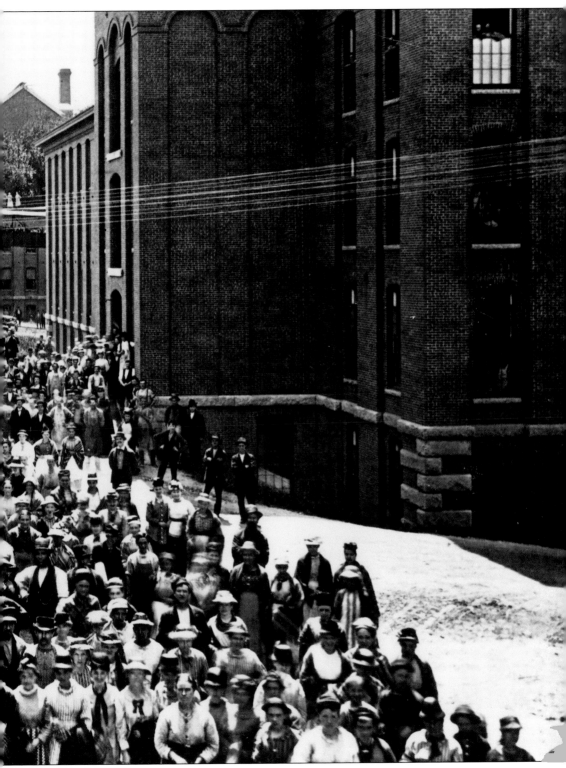

circa 1880. (MVHC)

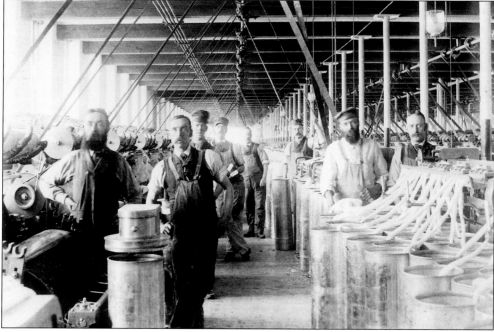

Workers pose in a card room at the Amoskeag Manufacturing Company. Photograph by J.G. Ellinwood, circa 1890. (RBP)

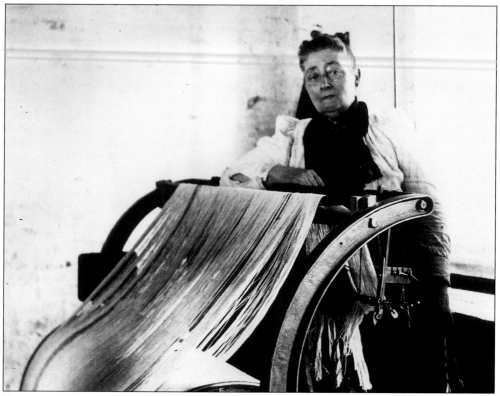

Drawing-in "girl." Photographer unknown, circa 1905. (MVHC)

Clovis Davignon, a young Canadian, relates his journey to join his parents, who were already employed at the mills:

"I had a little money and got as far as Newport, New Hampshire. I met some French Canadians at the station there, told them who I was and where I was going. They loaned me some money and I started for Manchester. I followed the river. My money didn't last long, and I worked on farms for my meals. I was about 17 then."

It took the young man six weeks to reach Manchester, where, after an adventurous trip, a good beating from his father, and a sound night's rest, he took a job in the mills the next day.

In the fall of 1893, several thousand Amoskeag employees found themselves out of work due to a temporary shutdown of the mills. The New Hampshire commissioner of labor issued the following report:

". . . no serious distress was experienced from the fact that a large number of the employees were Canadians, and they embraced the opportunity to visit their homes across our northern borders during their enforced vacation, where many of them remained permanently, and others until

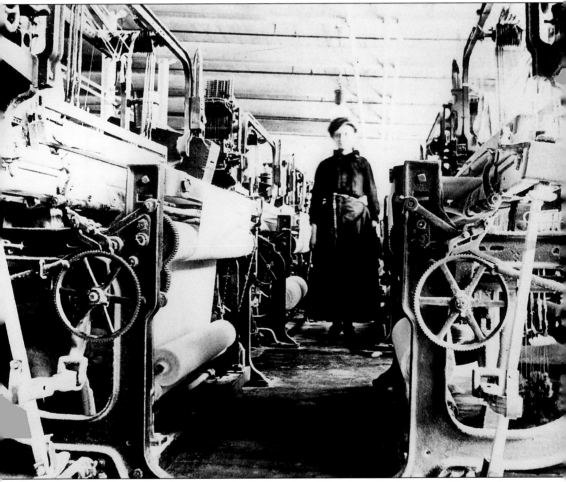

Marie-Anna (St. Denis) Boucher, weaver for the Amoskeag Manufacturing Company. Photographer unknown, circa 1910. (MVHC)

such time as their services were again required . . . During the winter a loan of $25,000 was authorized to provide work for the unemployed in Manchester through the Street Department, and charitable organizations did considerable work in furnishing pecuniary assistance and nourishing food at a nominal price to the unfortunate poor for a time . . ."

As the nineteenth century came to a close, working conditions improved considerably. The Company portrayed itself as a large family, and the workers within it as its children. A typical Amoskeag advertisement in French-Canadian newspapers read: "More than 15,000 persons work in these mills . . . it is true that the large company to which they sell their labor treats them as its own children." This industrial paternalism made itself known through a series of welfare programs.

Living space for a large segment of the labor force was provided by the construction of housing on 35.5 acres of company property. These tenements, considered very desirable by employees, offered good ventilation, sanitary conditions, and modern improvements. After five years of employment, workers became eligible for a home ownership plan.

Free dental care was provided for all children of employees. Two nurses and a surgeon were always ready to give medical attention to workers injured on the job. Electric runabouts enabled the nurses to get from one end of the mill yard to another quickly, and for families in need of care at home, two visiting nurses were on duty. A home instruction program was developed for mothers of infants.

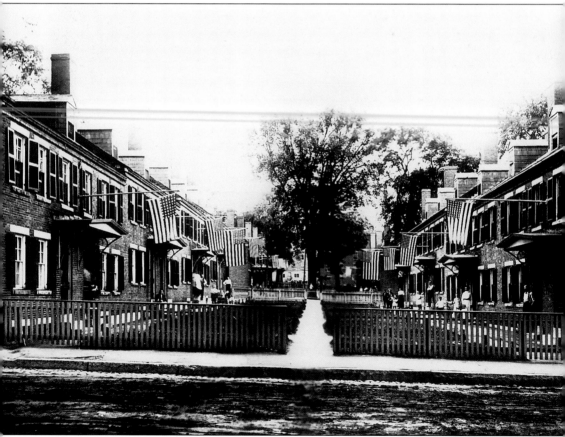

Families pose in their doorways at Amoskeag Company employee housing. Photographer unknown, circa 1900. (MVHC)

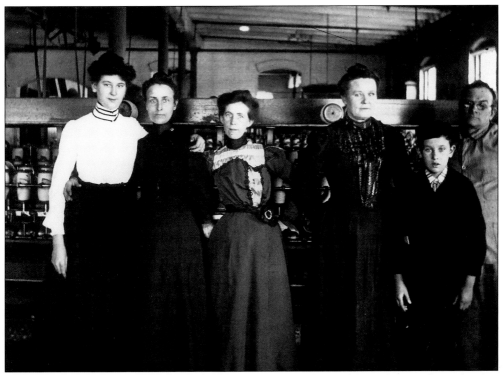

A group of operatives pose for a photograph at the end of the workday. Photographer unknown, circa 1905. (MVHC)

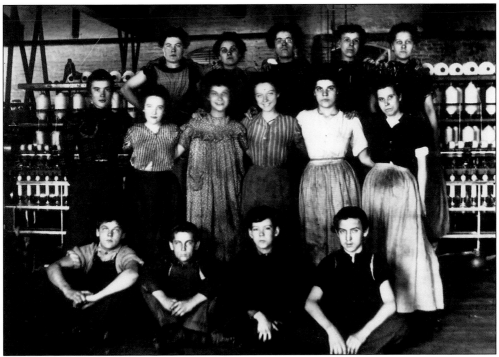

Young textile workers of the Amoskeag Company. Photographer unknown, circa 1905. (MVHC)

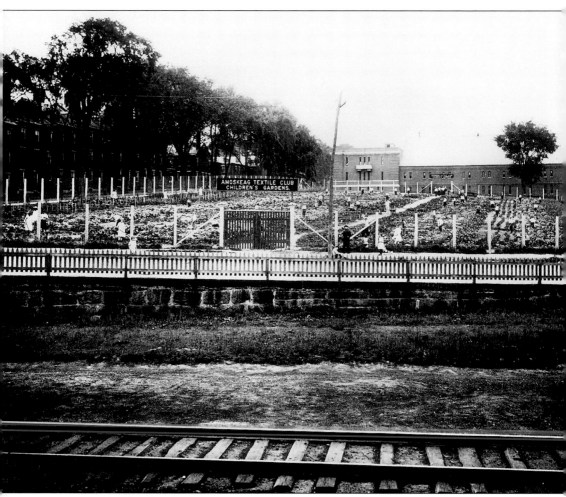

Beyond the railroad tracks are the Children's Gardens of the Amoskeag Textile Club. The June 15, 1913 edition of the Amoskeag Bulletin reported: "A boy may have his name at the end of his plot after July 1, provided weeds are kept down and his garden shows satisfactory care. The three boys whose plots show the best care up to September 15, will be given a trip to New Hampshire State College of Agriculture at Durham. On or about October 1, a fair will be held, open to all gardeners, at which time prizes will be awarded for the largest and best vegetables grown during the summer . . . Like the boys, each girl whose garden is a credit to the holder will have her name displayed within her plot. The three girls having the plots showing the greatest care will be given a trip to the Horticultural Exhibit at Boston in September. It is planned to hold a local flower show in September and award prizes for the best specimens of flowers exhibited, and as some flowers are more easily raised than others, the skill shown and difficulties overcome will be considered by the judges in awarding the prizes." Photographer unknown, circa 1912.

Textile and cooking schools were started, as well as a camera club. Plots of land were provided for employees to raise their own vegetables, as well as building a playground and garden areas for the children.

The Amoskeag Textile Club was formed with the following objectives: to advance the acquaintanceship of the employees with each other, to provide social recreation and amusement, to promote athletics, and to purchase or sell property for the benefit of the club's members. With these pursuits in mind, the club secured Varrick Park in 1912. The park was completely remodeled at a cost of $30,000, and renamed Textile Field. Fourteen thousand people turned out to witness the dedication on September 8, 1913. Through these welfare programs and a paternalistic attitude, management hoped to develop a permanent and loyal industrial labor force.

Because many Amoskeag employees lived next to the mills, their children had daily exposure to their parents' work experiences, and these became part of their consciousness from infancy. By the time they entered the mill, young people had become familiar with the entire work process. Childhood friends, cousins, and neighbors worked in the same room for years. Many workers met their spouses in the mill and continued to work there after marriage: entire lifetimes were lived in and around the mills.

In 1905 New Hampshire's Child Labor Law was passed, making the employment of children under sixteen illegal, but the Amoskeag Company continued to employ underage workers. In the September 1913 edition of *Good Housekeeping,* an article appeared attacking the system and its perpetrators:

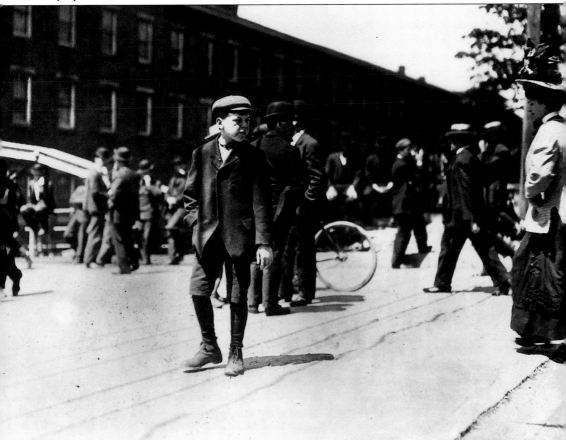

A child laborer of the Amoskeag Manufacturing Company. Photograph by Lewis Hine, 1909. (LC)

"Editor's Note. – New England—the New England of the Puritans and the oppressed in spirit who sought freedom—is guilty of more crimes against childhood than perhaps any other section of our country. Its mills lift their smoking chimneys high toward heaven, and from hill to hill one sees across the blue the signs of a busy land . . . By a simple story of what she found in New England Mills, Miss Hopkins draws an indictment of its smug complacence that should stir to action every citizen within its borders who puts his hope in human worth.

New England Mill Slaves
By Mary Alden Hopkins

The law in each of the New England states forbids the employment of a child under fourteen except under exceptional cases, and under sixteen without a certificate of age and the ability to speak, read and write the English language. So we say that child labor has been abolished yet; yet: The 1905 census counted 9,385 children under sixteen legally employed in the six states . . .

In every New England mill town you feel the dominance of the works. Usually the buildings lie along the river, curving to its bend . . . It would seem as if in this world of labor, little children had no part; yet little half-grown shadows flit among the others.

At nightfall the swarm emerging is in striking contrast to the morning. The workers become again fathers, mothers, lovers, children. Each takes on again the personality laid aside during labor . . . Everywhere children trickle through the crowd. A skinny little thing slides nervously along close to the wall. Her scant, black frock looks many times soaked and dried.

A wedge of little boys dressed in knickerbockers come flying out of the mill . . . They pause on the bridge to light their cigarettes and "kid" the watchman. They seem babies dressed in men's bad habits.

Children are Cheap and Don't Strike

. . . children, like most women, are docile; they never demand higher wages and shorter hours, and a good sprinkling of them hinders the formation of uneasy unions among the workers . . . Moreover children are cheap. Here are samples chosen at random from the federal report on the Condition of Women and Child Wage Earners: . . . In New Hampshire, a French-Canadian boy of fourteen, a spinner, averaged thirty-six cents a day the first eight months he worked. In Massachusetts, a Portuguese girl of thirteen, a doffer, averaged sixty-six cents a day. No adult could be hired at these terms.

. . . A . . . bill introduced into the New Hampshire Legislature last winter, illustrates the methods sometimes used to nullify child-labor laws . . . The truant officers are empowered to go into factories and withdraw illegally employed children. For two years now they have been doing this conscientiously.

. . . One child-employing manufacturer . . . began to lament bitterly. He was concerned not so much for himself as for 'the unfortunate children flung back into school when they panted to earn bread for their widowed mothers.'

'It is a bad law,' he cried.

'If it is such a bad law, why did you let us pass it?' inquired Hon. Henry C. Morrison, Superintendent of Public Instruction.

'We never supposed you would enforce it,' replied the aggrieved gentleman.

Mr. Morrison and his assistants enforced the law so systematically that the mills began to empty and the schools fill up. 'Really,' said some of the newspapers, 'this is going too far; of course we do not approve of child-labor, but—'

And on that 'but,' the 'practical men' introduced a 'practical' child-labor bill. This bill was presented to the House by Mr. Folsom of Dover: . . . No child under the age of 14 shall be employed, or permitted, or suffered to work, in, about, or in connection with any mill, factory,

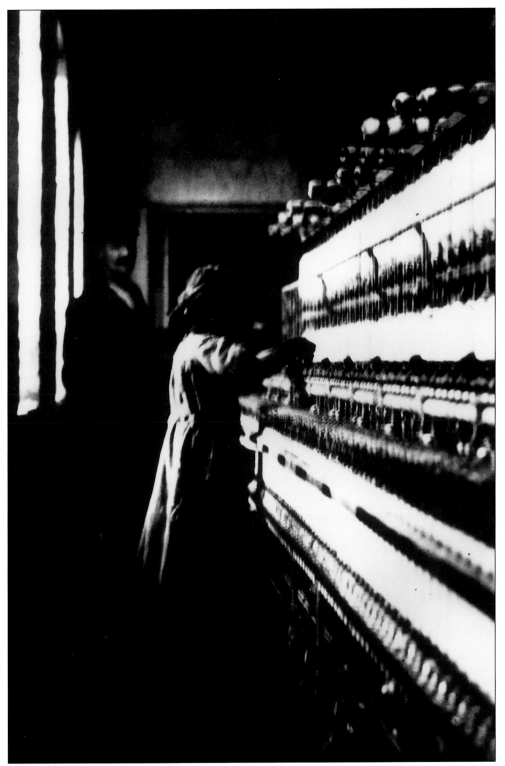

A child laboring at the Amoskeag Manufacturing Company. Photograph by Lewis Hine, 1909. (LC)

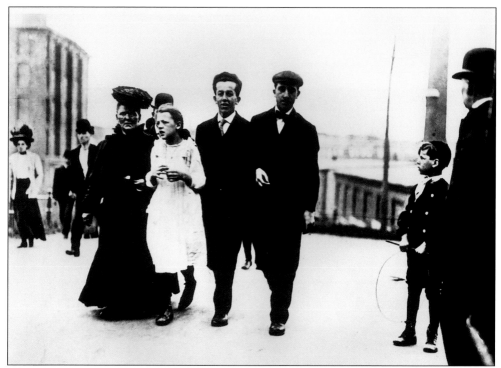

These three images are of child laborers of the Amoskeag Manufacturing Company. Photographs by Lewis Hine, 1909. (LC)

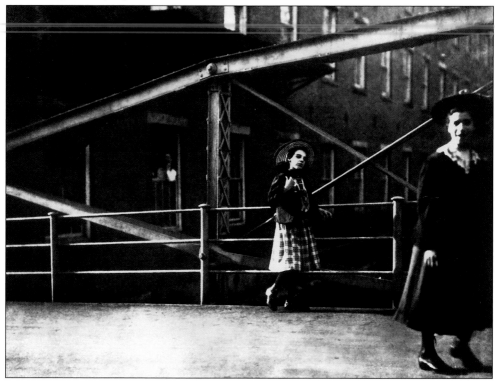

workshop, quarry, mercantile establishment, tenement house manufactory or workshop, store, business office, telegraph or telephone office, restaurant, bakery, hotel, barbershop, apartment house, bootblack stand or parlor, or in the distribution or transmission of merchandise or messages, during the hours when the public schools are in session.

. . . Following these provisions comes an innocent alteration instructing an employer to return to the child his certificate when he leaves—thus making it easy for him to give or sell it to some child whose need is greater than his own. Also, the insertion of the word 'approximate' before the child's description, to allow an inch or so shrinkage in height.

When these little ambiguities were pointed out, the Legislature decided not to pass the bill. . . Had this bill become a law, a child of six could have worked in the mills out of school hours.

. . . The days are past when farmers' daughters . . . coming from the country for a few years of factory life, could supply us with our fabrics. Today we employ Irish, English, Canadians, Turks, Armenians, Scandinavians, French, Germans, Hebrews, Greeks, and Lithuanians . . . Foreign names skillfully altered, birth dates cannily exchanged among cousins, and an ambitious youngster comes straight from steamer to factory with no pause in the wageless schoolroom."

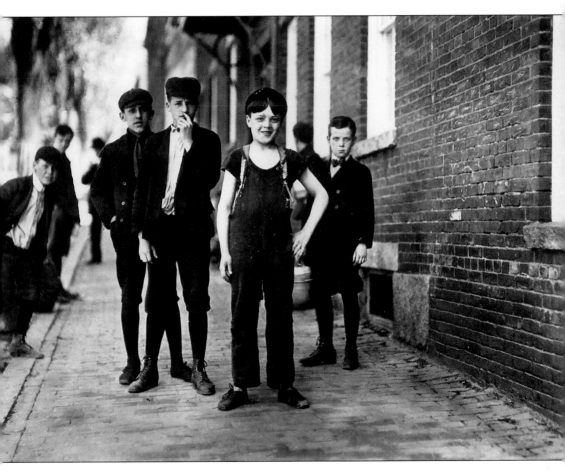

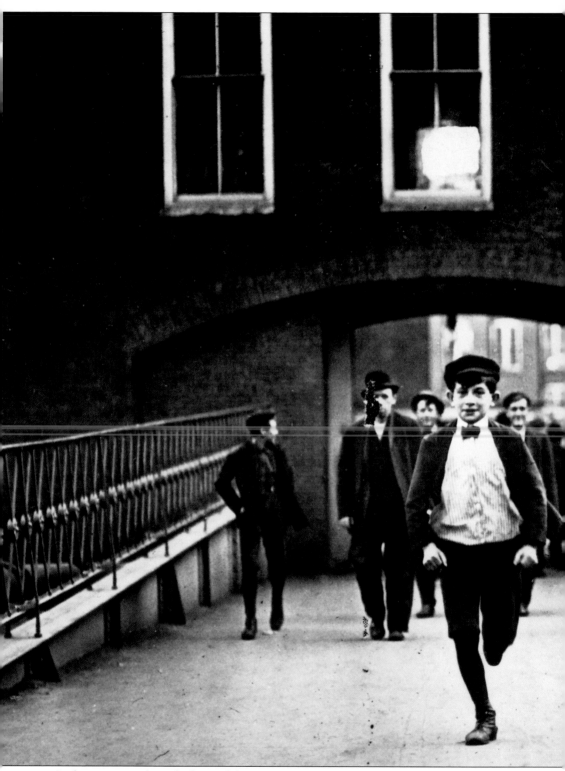

Smiles appear as the end of a workday arrives at last at the Amoskeag Manufacturing Company,

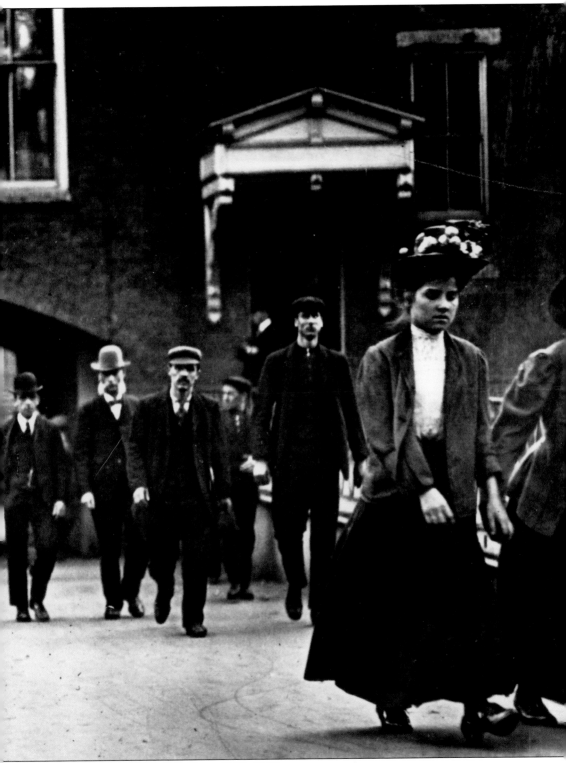

Manchester.Photograph by Lewis Hine, 1909. (LC)

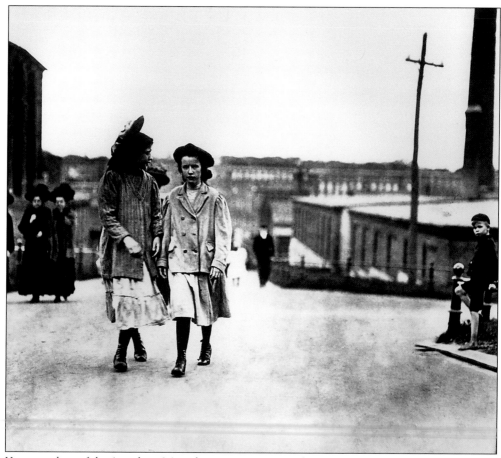

Young workers of the Amoskeag Manufacturing Company. Photograph by Lewis Hine, 1909. (LC)

The Amoskeag Company was sensitive about the practice and defended it in the local media. The November 15, 1913 edition of the *Amoskeag Bulletin* published a story entitled "Textile Paper Claims Yellow Writers Distort Facts," criticizing Mary Hopkins' article. This account expressed "surprise at the editors of *Good Housekeeping* with their high ideals, for falling for such rot, without proper investigation." It went on to justify the practice with the following commentary:

"Isolated cases are cited and skillfully written to apply to the entire New England industry, and it does not require careful reading to realize the apparently willing misrepresentation of the New England textile industry.

Child labor is a condition and not a theory. The textile mills are made the goats by the theorists and reformers quite naturally, because thousands of boys and girls are earning a living wage and learning a trade in these mills and not two in one hundred in New England are in the class so vividly portrayed in the story.

Rather than being a curse, the little Vermont mill she tells about is a blessing and is so recognized by the people who have gained a comfortable living by work in the mill. The boys and girls in the vicinity of this mill and of all mills in New England in the small towns, grow up with the ambition to learn the business and have a trade that makes them independent.

What would become of such boys and girls without the mills? They would work as farm hands or kitchen help to get money to go to the big cities, and then what? It is not pleasant to even guess in five cases out of ten. The cities are overflowing, the temptations to leave the straight and narrow path are increasing and if there is a social blessing anywhere it is the little country mills that give all people of the town and nearby community steady work."

In 1909, social documentary photographer Lewis Hine came to Manchester to record child labor in the mills. His concern for the exploited and underprivileged and his training as a sociologist motivated him to use a camera to create his personal photographic view of the effect the free enterprise system was having on these groups of people.

In the hope of eliminating child labor, Hine traveled as far south as Texas making photographs for the National Labor Committee of New York which was campaigning against the practice. He often had to misrepresent his intentions for taking a photograph with his five-by-seven-inch view camera in order not to scare off underage laborers or arouse suspicion on the part of mill management. The chiaroscuro effect he obtained in the interior portraits of Amoskeag's child laborers, coupled with the scale of the large machinery they posed next to, created powerful images of the very young children forced to work so that they and their families could survive. These bleak images of industrial life appeared in books, magazines, pamphlets, lantern slide presentations, and exhibitions, and helped to promote the passage of strict labor laws governing child labor.

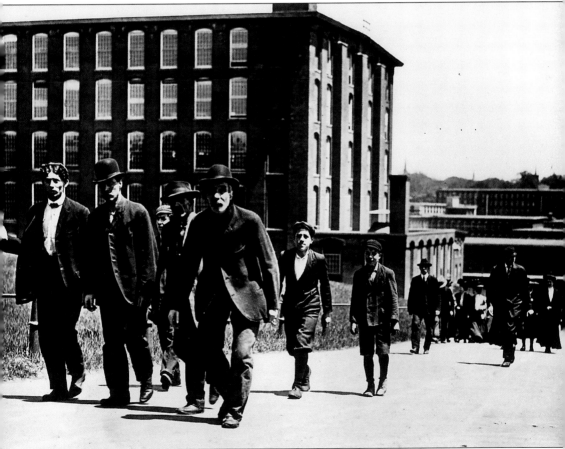

Amoskeag employees emerge from the mills for lunch. Photograph by Lewis Hine, 1909. (LC)

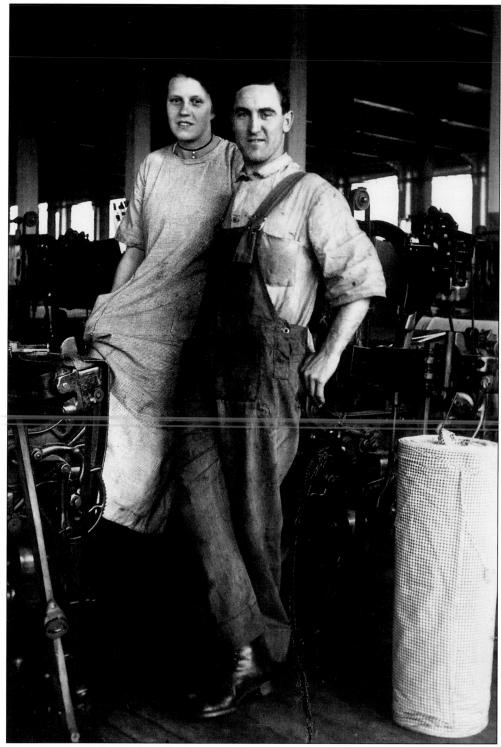

The working atmosphere in the mills often permitted men and women to become friends and to sometimes marry. Photographer unknown, circa 1920. (MVHC)

By 1912, the Amoskeag Mills had become an international melting pot. Besides the Canadians, who comprised 40 percent of the work force, the Company also absorbed immigrants from Germany, Sweden, Poland, Lithuania, and Greece. The following are some telling statistics for the Amoskeag Corporation in the year 1912:

Annual Payroll: $7,800,000
Workforce: 15,500 people; 8,500 men and 7,000 women
Production: 50 miles of cloth woven every hour
Cotton consumed: 54,600,000 pounds per year
Average full-time wage for a 58-hour week: $10.55

In July 1914 the Amoskeag Manufacturing Company claimed the proud distinction of having just completed the largest American flag ever made. It measured 95 feet in length by 50 feet in width and was designed to be flown from a pole 285 feet tall. The bunting of the flag was spun, woven, dyed, and assembled in the pattern department of No. 11 Mill. The width of each of its thirteen stripes was 47 inches. The great stars upon its blue field were constructed within a

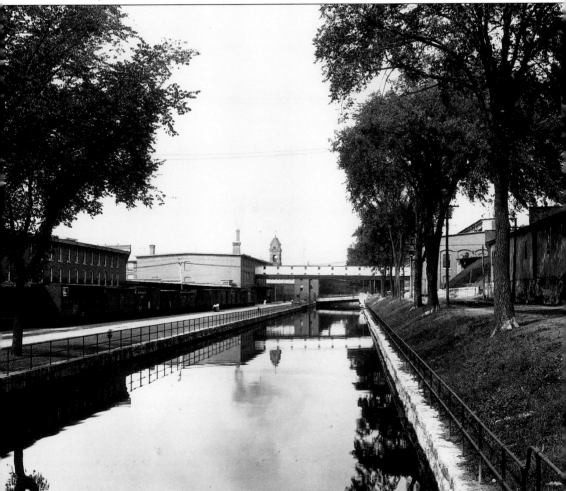

Looking north towards Granite Street along the canals. Photograph by the Detroit Publishing Co., 1908. (LC)

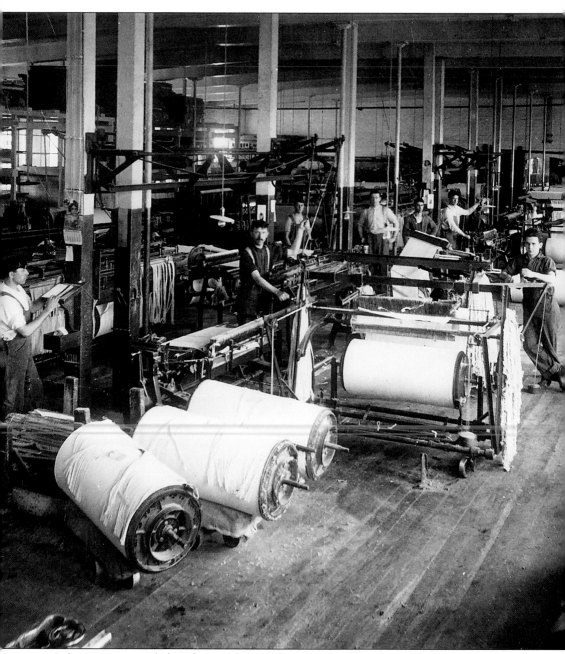

Laborers inspecting cloth at the Amoskeag Company. Photographer unknown, circa 1920. (MVHC)

39-inch circle and measured about 3 feet from point to point. The blue field was 38 feet in length by 27 feet 5 inches in height. The stars were placed 4 feet 9 inches between centers longitudinally and 4 feet 3 inches vertically. The stars alone weighed 9 pounds while the completed flag weighed two hundred pounds. A photograph of the flag, suspended from the cornice of No. 11 Mill, was taken after a suitable point was found from which to hang it,

since its dimensions were greater than the height of the six-story building. The week that the great flag was shipped to Chicago, the Company paper, the *Amoskeag Bulletin*, ran the following announcement:

The August Shut-Down
Notices posted in the mills today giving
information that mills will suspend work from
August 28 to Sept. 8

"Notices will be posted today throughout the plant of the Amoskeag Manufacturing Company and the Stark Mills, notifying the thousands of employees that the annual summer shutdown of these big concerns will begin on Friday night, August 28. Work will commence again on Tuesday morning, September 8.

Many of the employees have been looking forward with some trepidation to a longer closing time, for some reason getting the idea that dull times were about to hit the city and the *Bulletin* is glad to inform its readers that the shutdown is of such a short duration. Only a little over a week's pay will be lost to the mill workers and this fact is sure to be the source of much gratification on all sides.

The different departments of the Amoskeag Company are running practically to the full capacity and in some instances continued night work is found necessary to keep up with the demand.

While mills and factories in other cities are shutting down for different periods of time, some of them indefinitely, the mill workers in this city are practically fortunate in this respect. Aside from the regular summer vacation, each year, it has been a long time since there has been any enforced idleness, especially on account of lack of orders. This is due, in every respect, to the fine system of management governing both the manufacturing and selling ends of the Company's business."

The year 1915 saw the construction of the last of the Amoskeag complex buildings. One hundred and thirty acres of floor space in fifty buildings were occupied by machines spewing forth six hundred miles of cloth a day. Manchester earned the reputation as the "strikeless city." Labor unions met difficulty in organizing the workers because of the ethnic and language barriers.

During World War I, the cotton textile industry continued to prosper. This prosperity was not to last. After World War I, Amoskeag, along with most other New England industries, declined. An abundance of inexpensive labor and close proximity to the cotton crop enabled mills in the south to produce high quality products at a much lower price. With hard times on the horizon, Amoskeag posted a notice to all employees on February 2, 1922:

Commencing Monday, February 13, 1922, a reduction of 20 percent will be made in all hour and price rates in all departments of the Amoskeag. At the same time the running time of the mills will be increased from 48 to 54 hours per week, in accordance with the schedule posted herewith."

The overall effect of this was a 10 percent reduction in pay for the workers.

On February 3, 1922, Dennis M. Fleming, president of the Manchester Textile Council, requested a strike permit from the emergency council of the United Textile Workers of America. Two days later a meeting between James Starr, vice president of the United Textile Workers, and Amoskeag laborers resulted in a nearly unanimous vote to strike, forcing agent William Parker Straw to close the mills on February 13, 1922. Samuel Gompers, president of the American Federation of Labor, encouraged the strikers. Commissaries were rapidly established so that strikers would have free food.

On Monday, June 5, the gates of Amoskeag's Coolidge Mill were opened after Governor Brown suggested that the mills open one unit of their plant, "to afford employment to former employees who are out on account of the strike and who are needy, in some instances subsisting on charity, and desiring work." The manufacturers saw the governor's suggestion as an opportunity to break the strike. Officials counted 127 people going through the gates. As the Coolidge Mill was the largest single plant of the Amoskeag and required at least 1,100 workers for full operation, the strikers had achieved a notable victory.

Despite the efforts of the union to provide food for the strikers, nine long months of strife quickly depleted what little financial resources the strikers had. Union Vice President Starr recommended that the strike be called off saying, ". . . I know that the real and permanent victory for the forty-eight-hour week is not to be won in the offices of the textile corporation, but in the legislative halls of the State House." Seventy percent of the strikers voted to return to work under protest. Thus the strike ended as it started, seeking a forty-eight hour work week through the state legislature. Amoskeag's labor force ultimately suffered a major defeat, and their loss was hailed a victory in the business world.

It was a short-lived victory for the firm. The Amoskeag Company now became the victim of a changing world and a changing economy. Many large accounts were lost during the strike. In addition, stiff competition from southern mills continued to grow. More strikes were to come, and finally . . . the Great Depression of the 1930s. Unable to withstand all of these forces, the Corporation permanently closed its doors on Christmas Eve of 1935. The Amoskeag Manufacturing Company became a lost, silent city.

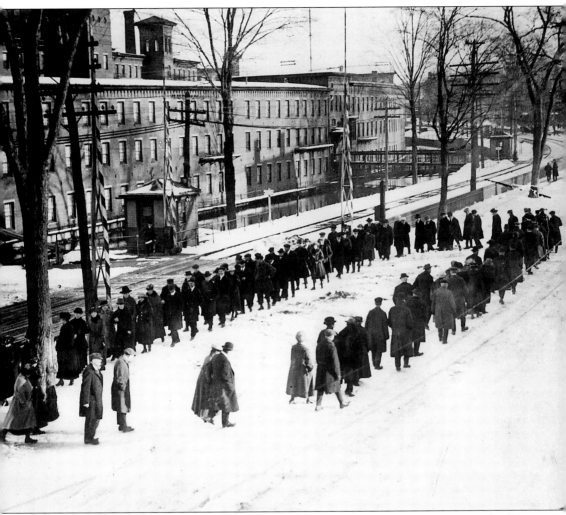

The caption on the police department record reads as follows: "Massive picketing in front of mill entrance." Photographer unknown, March 13, 1922. (MPD)

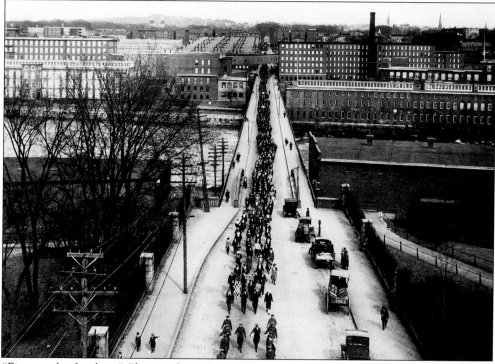

"First parade of strikers." Photographer unknown, April 10, 1922. (MPD)

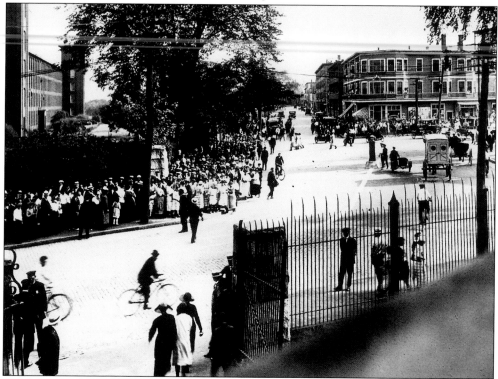

"5:30 closing time. Operatives leaving were hooted at." Photographer unknown, June 5, 1922. (MPD)

Three

ALICE LACASSE OLIVIER: PORTRAIT OF A MILL FAMILY

Alice Lacasse Olivier was born in 1915 and grew into adulthood during the Great Depression. This oral interview conducted by the author reflects what life was like for her and her family, as well as for other Americans who struggled to succeed during this era:

"My name is Alice Lacasse Olivier. I was born in Manchester, on Pearl Street. My mother and father came from Canada. They were immigrants in the early 1900s. They both worked in the mills. When they met in the mill, they were living in boarding houses. I suppose it was love, but love has many different faces. It was more to have a family, to be together, to have someone. They were married here at St. George's Church in Manchester in 1910 and a year later they had a little girl, but they lost the first little girl. My father always talked about her like it was something he wished he had kept. He had twelve, but he always missed her.

He never had any other job. He started in the spinning room, sweeping or whatever, and he worked his way up to a second hand which was the second in charge, which was something for a person in those days, because he had no education. He could fix a frame with his eyes closed. That's how smart he was. By the way, he spoke fluent English, but my mother always thought if she spoke English, she would lose her religion. We all spoke English very fluently but my mother would never learn.

As a young child we moved to 313 Canal Street on the corner of Mill and Canal and had twelve rooms because we were a large family and we were growing. We were surrounded by boarding houses. In those days rooming and boarding houses were the thing because that's where people lived who didn't have a home, didn't have a family.

We went to St. Augustine School. We used to travel on foot, oh, at least a mile. We used to travel four times a day. We always walked. When we came home from school, our job was to

75

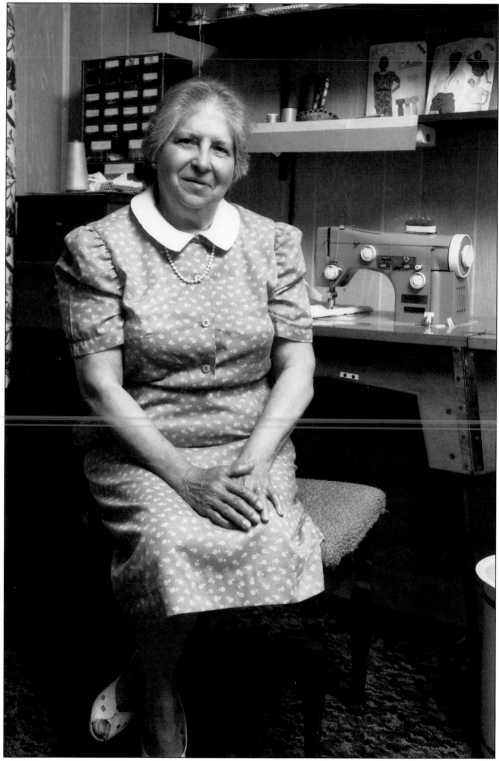

Alice Lacasse Olivier. Photograph by the author, 1986.

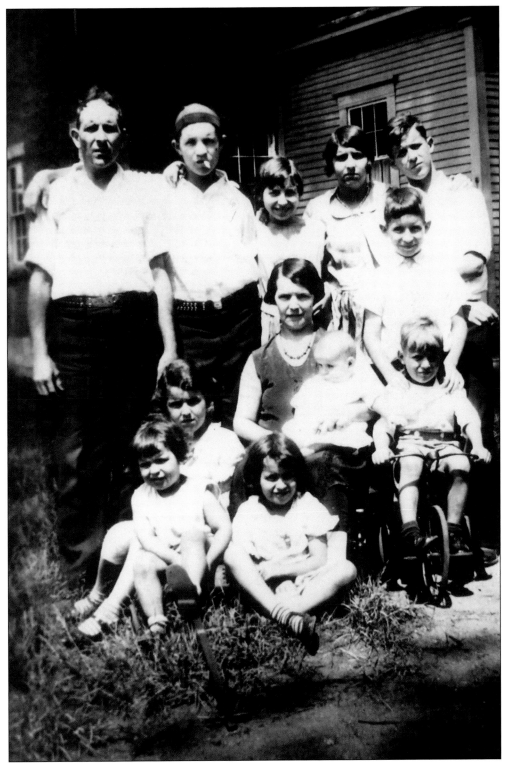

The Lacasse family gathers for a portrait in the backyard. Photographer unknown, circa 1930. (ALO)

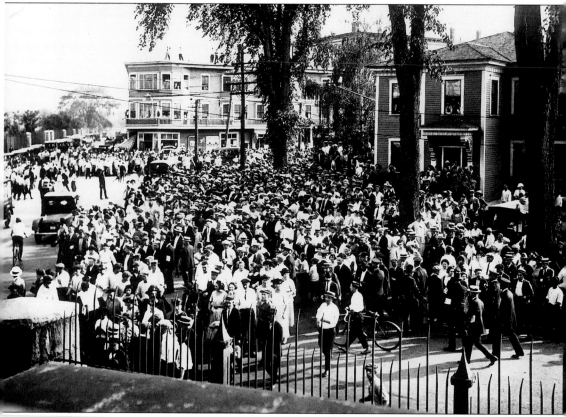

This photograph was taken at 5:33 p.m. on Wednesday, June 7, 1922. The Manchester Police Department reported the following: "Crowd jeering and hooting at operatives as they attempt to leave mill through Coolidge gate. Union officials, by waving their hands, attempted to keep crowd quiet, but were unsuccessful." Photographer unknown. (MPD)

bring dinners in the mills. My mother had regular customers; she used to fill lunch boxes and we each had to carry lunches to different parts of the mill yard and we'd have to run because we had an hour from school to go down and bring them and then eat and get back to school. We didn't waste any time. To earn more money, my mother used to take boarders at home from the mills where my father worked. The gate to the mill yard was right in front of our house. So when the bell would ring, the people would come out and she would serve them first, and then we would eat. She'd always have six to eight people for dinner.

My two older brothers graduated from St. Augustine School at eleven and twelve years old, both of them in French and English. But when I finished the sixth grade, my father was the only one working. In those days they didn't stress education for girls very much. They decided that I should go to work. I was twelve years old then, and there was a boarding house next to us who offered my parents a job for me at $3.50 a week washing dishes. So they put me in public school which was a complete disgrace in those days for us as a family, to leave the parochial schools. But my parents, I'm very proud to say, never had help from the city, amazing enough, and we were poor.

My mother used to make all our clothes. People would give us old clothes. I remember sitting on the floor and helping my mother rip out old coats And she'd make us beautiful things. She

was a beautiful seamstress. I mean, it sounds terrible, but it wasn't. It was lovely. She'd knit our hats and mittens and stockings. They used to sing a lot, and we were brought up with singing in the house, and prayer, of course, that was a must in our family. Every day after supper we'd all kneel down to say the beads. Those, today, are very happy memories for me.

The strike was in 1922, so I was about six or seven years old. Nine months my father was out of work. I remember my mother talking about standing in line to get flour and beans at the union. They used to give food to the people and of course we never had meat. She used to tell us about the strike and especially she told us that the men didn't want to go back to work. They were afraid to be called scabs and they were afraid to be hit by the people who were striking. So the women in the block where we lived on Market Street banded together and they said, 'We're sick of this. We're sick of starving. We're sick of seeing our children sick.' They decided to go to work. It was the women who went back to work first and my mother went, and then gradually the men. But they didn't gain anything. They lost, as a matter of fact. Their pays were cut; it was terrible.

I don't know how they did it. I don't know what kind of courage these people had. I speak of my family, but it was generally the same thing in every family. There was no money, there were long hours of work, and that's all they did was work and pray. Religion meant everything to them. If it hadn't been for the Church, I don't think these people would have survived.

When I graduated from Franklin Street Grammar School I had to go to work full-time. I had been working in a boarding house and I had been giving my mother $3.50 a week and getting two meals a day which was a big help for my family. My mother, who spoke very little English, didn't want me to go into the mills, but she went down to the office with me and spoke to somebody there who spoke French so that they could get me into the cloth room. She wanted me to be safe. Well, the cloth room was the finishing room where they took the woolen goods and it was one of the best parts of the mill to work in. It was very quiet in there.

The cloth would come by in front of you, and you would press a peddle every time you wanted to move it. You'd have to look at the cloth to see that it was perfect to go on the market. If it wasn't, you had to take the knot out, or the bunches out, and clean it up. We started work at 6:45 a.m., til noon, and then you'd work from 1 pm until 5:15 p.m. You worked Saturday from 6:45 a.m. 'til noon. That was fifty-four hours a week and we were making $13.98 a week.

As a matter of fact, I was very proud to be able to bring home $13.98 to my parents because they needed it so badly. I never felt that I had been deprived because they had always been good to us. I can't really say we ever lacked anything for the times. We ate well and had good beds, and clothes. I was fairly decently dressed to go to work.

Around me were all young girls my age who had not gone to high school for whatever reason. They were from different ethnic backgrounds. There were Polish and Greek and they'd speak their own languages, and I would speak French to whoever I was with. Our boss' name was Peter Flynn. He was strict. If he'd catch you talking he'd come over and really give it to you. It was a privileged place to work and everybody wanted to keep their jobs.

It was fun for me because the man who was the second hand there, under Peter Flynn, I had baby-sat for him, so I knew him very well. His name was Tommy Regan. As I progressed there I got better jobs. I learned a better trade. They put me on woolens which was much harder because you had to mend the woolens and you were on piece work, so you made more money, but you had to work. If you didn't work, you just didn't make it. About three years later, I was making sometimes $35 to $40 a week. I was making more than my Dad. The most he ever made was $25 a week, and he was second hand. So it was a good-paying job for the time. I worked there five years until the mills closed. I was fourteen when I started.

I loved my work. I had learned sewing and knitting and doing all kinds of things like that at home, so it was right up my alley. It came very easy to me. I never felt that I had been cheated in any way.

It was kind of understood that at twelve, thirteen, fourteen years old, you went to work in 1930, 1931. But my parents were determined that their children were not going to go in the

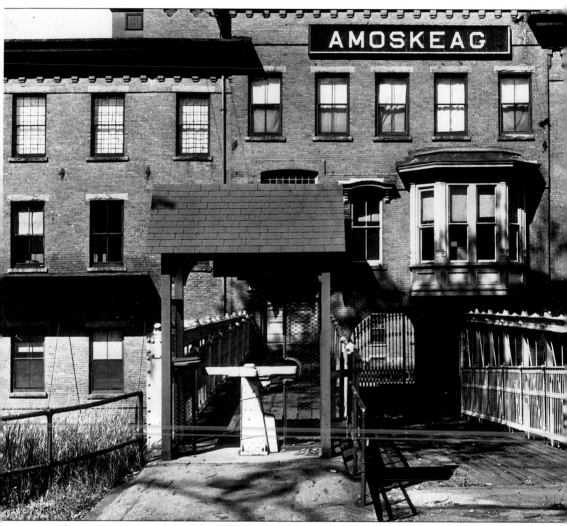

The main entrance to the east side of the mill yard from Canal Street. With the closing of the Amoskeag Mills, 11,000 jobs were lost, creating economic and social problems for the entire population. Photographer unknown, circa 1936. (NA)

mills. They had spent a lifetime in the mills working. My father worked in a spinning room. It was unbearable. You couldn't hear yourself think. They wanted their children to have an education. People thought he was a little crazy when he let his sons go to school. Because of the family that he had and the poverty that we were feeling. To let these boys go and not earn one dime was really incredible in those days. My father had to suffer all that humiliation. The people who worked with him used to ridicule him and say, 'You're crazy.' I saw the others grow up and finish grammar school and go into high school. My sisters all went to St. George's High and the boys all went to seminary.

The day that my father stopped working, he never received a cent. My mother didn't have a dime. My father died when he was forty-four years old and left my mother with twelve children. All we had when my father died in 1935 was $1,000 insurance. There was no Social Security,

there was nothing. And my father had worked a whole lifetime. It was awful. My mother went back to work full-time from 11 p.m. until 7 a.m. She'd come in in the morning and give breakfast to the children before they'd go to school. You can't imagine what kind of life it was for us after my father died. It was hard when he was living but when my father died, it was awful. I saw my mother cry so many times.

I was very sad when the mills closed down. I was the support of the family, really, and they were taking the rent out of my pay. I went to work for the Works Project Administration. There was one per family. I was only making $13 a week. I was working on power machines making quilts and overalls and shirts, so I learned a lot, again. I was able to gradually get myself into a shoe shop because of my background in sewing. I really wanted to get in, but there weren't very many jobs. I got a letter of recommendation from the supervisor at the WPA building where I was working and I went in to one of the shops and they hired me on the basis of that letter. There were no more mills at this point so you had to do something else. I stayed there until I got married.

When I became pregnant I left and didn't work for many years. My husband worked two jobs. I stayed home. I sewed a lot and did a lot to earn money at home but I didn't work outside for many years until my children were old enough. I worked at the Elliot Hospital as a supervisor in housekeeping, and I decided to go to high school. I graduated in 1976 from high school. I had cried so much because I couldn't go, so I was pretty proud. I had my children, my grandchildren, sitting there watching the graduation."

The closing of the Amoskeag Manufacturing Company in Manchester left many laborers idle. During 1936, 29 percent of Manchester's families received general relief assistance or Work Projects Administration work. Photographer unknown, circa 1936. (NA)

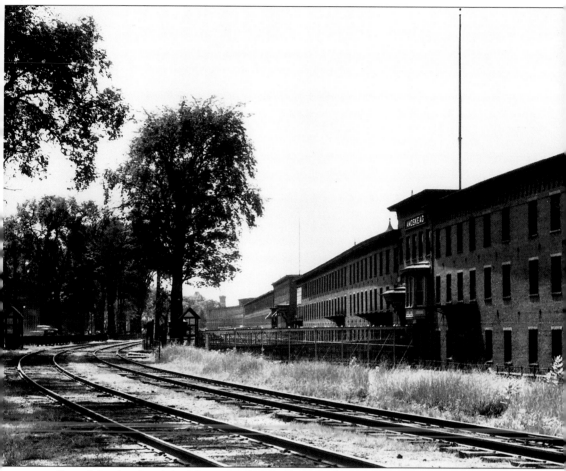

Part of the abandoned Amoskeag complex, in a view looking south from Canal Street. Photographer unknown, circa 1936. (NA)

Four

THE IMMIGRANT
EXPERIENCE

The rivers of New England, with their seemingly inexhaustible water power, gave rise to the manufacture of cotton and woolen textiles which formed the basis for unprecedented industrial expansion in the nineteenth century. A powerful group of Boston businessmen, the Boston Associates, founded a mill at Lowell, Massachusetts, which became the nation's leading cotton textile manufacturer prior to the Civil War. The Boston Associates went on to build additional mills across New England, including sites in Nashua and Dover, New Hampshire, Lawrence and Holyoke, Massachusetts, and Saco, Maine. Mill towns were constructed around the mills themselves, including housing for mill workers, streets, parks, and commercial areas.

Industrial growth quickly moved north, up the Merrimack River Valley and into New Hampshire. The Boston Associates founded the most important of their ventures in Manchester: the Amoskeag Manufacturing Company included thirty major mills and covered about eight million square feet of floor space.

An undertaking of such vast proportions required equally large numbers of laborers in order to function. Local sources of labor were rapidly absorbed into the mills but were fast exhausted, as many local workers rejected the long hours and difficult working conditions imposed upon them. Mill agents were required to look beyond the immediate locality for labor, and their search for new hands coincided with the flood of immigrants from Europe and Québec into the United States in search of a means to support their families. These immigrants came from agricultural settings, which were suffering from a combination of poor economic conditions and unscientific methods of farming.

By far the largest ethnic group to work in the mills of the Merrimack Valley was the French Canadian. In 1910, French Canadians comprised 35 percent of the working force in the Amoskeag and 38 percent of the population of the city of Manchester. Early immigrants came largely from the farms of Québec. Most farm activities were oriented toward self-sufficiency, and contact with the outside world was minimal. Farming in French Canada changed little during the nineteenth century. Money needed to purchase the necessities the farm could not provide was earned through the sale of wheat, which became the major cash crop of Québécois families. Between 1827 and 1844, there was on average a 70 percent drop in wheat production

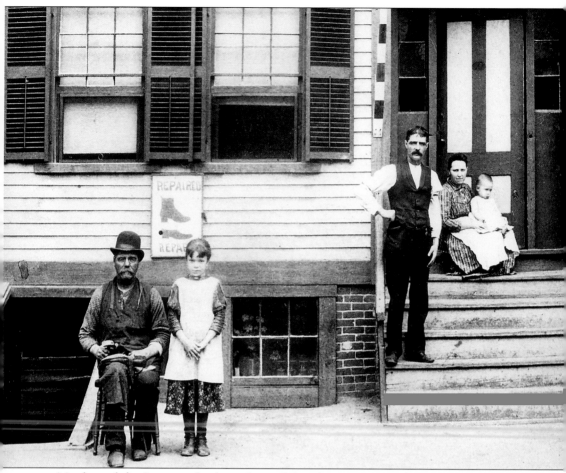

Members of the Savageau family in front of their home at 1419 Elm Street. Photographer and date unknown. (MVHC)

due to depleted soil fertility and a wheat blight. In 1851, 84 percent of Québec's population was agricultural; the effects of the fluctuation in the wheat crop were disastrous. The English had limited the land available for French settlement and by the mid-nineteenth century, the shortage of farmland had reached critical proportions. Because there was not enough available farmland to support the over sixty thousand French Canadians, farm families were faced with extreme poverty. The property of many farmers who were unable to meet their financial obligations was seized and the sale of confiscated farm property on the parish steps was not an uncommon sight.

The lack of available farmland, the economic and physical hardship brought on by the failure of the wheat crop, and England's refusal to allow adequate French Canadian representation in government sowed the seeds of rebellion. During 1837 and 1838, two thousand poorly armed rebels rioted in several villages to protest unfair English treatment. These farmers, armed mostly with pitchforks and other farm implements, met with merciless defeat at the hands of eight thousand soldiers. The failure of the revolt made clear to the French Canadians that the government would not be responsive to their needs. In the midst of a general economic depression, a route out must have seemed attractive.

The completion of a railroad connection between Canada and New England provided the mass transportation necessary for a large-scale movement. The railroads hired French Canadians as ticket agents in both the United States and Québec, and they were guaranteed a 50¢ commission for each passage sold. Railroad agents across New England worked closely with industrial manufacturers, often functioning as quasi-employment agents, in informing migrants where job openings existed. For less than $10, a Québécois immigrant could ride from Montréal to almost anywhere in New England in about a day.

By 1869, New England was producing about 75 percent of the nation's cotton goods, 67 percent of its woolen goods, as well as almost 60 percent of its boots and shoes. As a result, the region presented many employment opportunities for Québécois immigrants. The availability of transportation, coupled with the availability of work, was particularly appealing.

A 5:00 a.m. bell would summon workers to a twelve-hour work day in which they would have to endure extreme heat, stifling humidity, deafening noise, and the constant threat of injury or death. The air was thick with cotton dust, which caused lung disease, and the stress of the seventy-two-hour workweek caused many to fall ill, and some, especially young children, to die.

In spite of these terrible conditions, some immigrants spent whole lifetimes working in the mills. The August 1, 1919 issue of the *Amoskeag Bulletin* contains the obituary of Séraphine Cayer:

"Mrs. Séraphine Cayer, a veteran mill employee, passed away on Thursday, July 17. She was born in Canada and was nearly seventy years of age and was a resident of this city for fifty-five years, fifty-four of which she had passed as an employee in the Amoskeag mills. She came to Manchester to settle as a young girl, the family being one of the first French families to locate

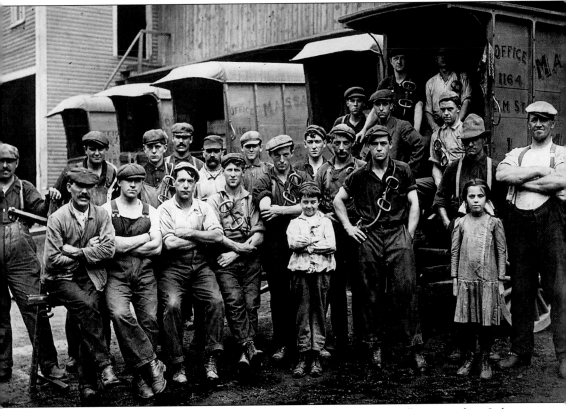

Employees of the Manchester Coal and Ice Company. The firm harvested ice locally at Massabesic Lake, located just a few miles east of the city. Photograph by Boulanger et frères, circa 1900. (MVHC)

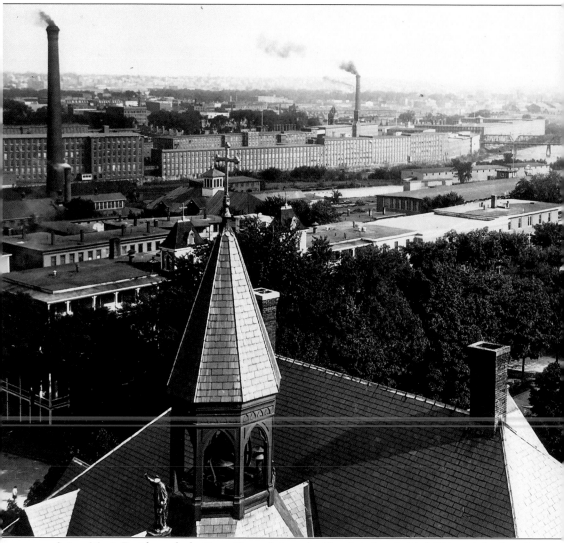

Sainte-Marie Parish overlooks Notre Dame de Lourdes Hospital, founded in 1894, and the Amoskeag Mills. Photographer unknown, circa 1925. (MVHC)

here. She first entered the employ of the Company in old No. 3 central division carding room, later going to the carding room in the Amory mill.

Transferred to the Langdon, she remained there, working for Overseer Herbert F. Alston when she passed away."

The extensive use of women and children was a characteristic of the textile industry from its earliest days. While a large family had become an economic burden to the Québec farm, it was an asset in the New England mills. From 1870 through the early 1900s, the bulk of the French Canadian labor force in the textile industry consisted of women and children. Men often found work in other occupations.

86

The mills provided single and separated French Canadian women with an economic independence unusual for women of that period. On the farm, they worked hard but received no money for it. Mill work gave them money of their own. The potential for children to find work in the mills also attracted widowed mothers who were unable to support their families alone; with the help of income from the children, the family was able to survive. Out of economic necessity for the workers, and to attain the cheapest labor for the mills, school attendance laws and minimum age labor laws were often ignored. Due to the large numbers of child laborers, French Canadians were often accused of exploiting their children. However, child labor was prevalent in the textile mills long before the French Canadian immigration, and the French Canadians simply followed a long-established custom reinforced by necessity.

By the turn of the century, over half a million French Canadians were living in New England. This group of people came to be known as Franco-Americans. In many mill towns, the Franco-American neighborhood was called "Le Petit Canada," or Little Canada. At times, entire populations of rural Québec villages were transferred almost intact to mill town neighborhoods. Often the only housing available to these new immigrants was tenement apartments, where

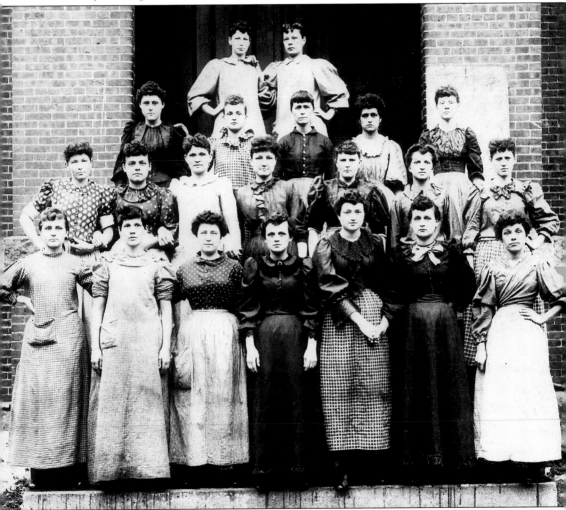

Many French Canadian women found employment in the Amoskeag Manufacturing Company. Photographer unknown, circa 1895. (MVHC)

a three- or four-room space might be home to fifteen family members. As time passed, many Franco-American families were able to save money in order to move into better living quarters. Once the French Canadian laborers had become established, Québec's businessmen and professionals were also attracted to New England. These French-speaking settlements completed Le Petit Canada and added to the social dynamics and prosperity of the city.

In addition to their struggle for economic survival, Franco-Americans were also concerned with the survival of their ethnic heritage. The social doctrine of "La Survivance" was the focal point around which Franco-Americans worked to establish a cultural base. The philosophy of "La Survivance" revolved around the strongly held belief that the preservation of French culture and religion was dependent upon the preservation of the French language. Franco-Americans struggled to maintain their language in the United States by founding churches, schools, newspapers, and ethnic societies where only French was spoken.

However, their resolve not to assimilate seemed to threaten the English-speaking population of New England. As a result, prejudice and discrimination against Franco-Americans and other non-English-speaking ethnic groups became common. The following article, which appeared in the October 1, 1919 issue of the *Amoskeag Bulletin*, was representative of the attitude toward non-English-speaking people:

Must Learn English
In Order to Keep at Work Some Must Go to Night School

"In accordance with the state law passed last winter by the legislature, the Amoskeag corporation has sent out the past week, large posters warning all their employees who cannot read or speak the English language to comply with the law. The statute provides that after October 1, 1919,

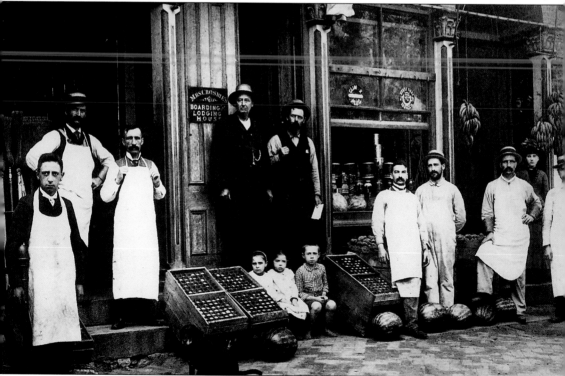

The Turcotte family, after having emigrated from Saint-Pierre-les-Becquets, Québec, established a grocery store on Elm Street in Manchester. Photographer unknown, circa 1890. (MVHC)

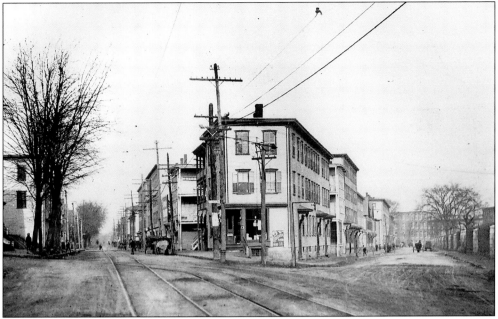

Looking north up South Main Street. These tenements, located across the street from the mills, constituted the heart of "Le Petit Canada," or Little Canada. Photographer unknown, circa 1905. (MVHC)

Vigneault and Pigeon, liquors. Photographer unknown, circa 1915. (MVHC)

"My father was a cigar maker. He learned the trade from his father who was a cigar maker also. My dad opened the shop on North Main Street on the West Side. It was a little French country of itself, the West Side was. They had everything there." From an interview with Marcel Olivier by the author. Photographer unknown, circa 1915. (MVHC)

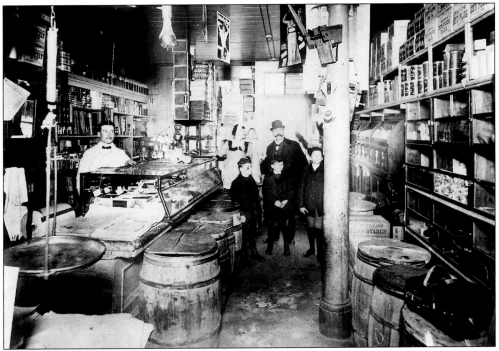

The Manchester City Directory featured the following advertisement for Verrette's grocery store: "M. Verrette, Wholesale and Retail dealer in Groceries and Provisions . . . choice of beef, pork, mutton, vegetables, oysters, clams and poultry . . . a specialty: the best tobaccos." Photographer unknown, circa 1920. (MVHC)

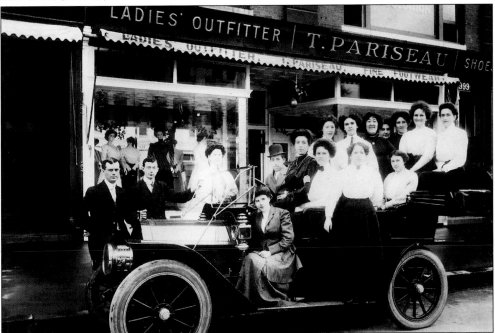

T. Pariseau, women's apparel, on Elm Street, Manchester. Photograph by Ulric Bourgeois, circa 1915. (MVHC)

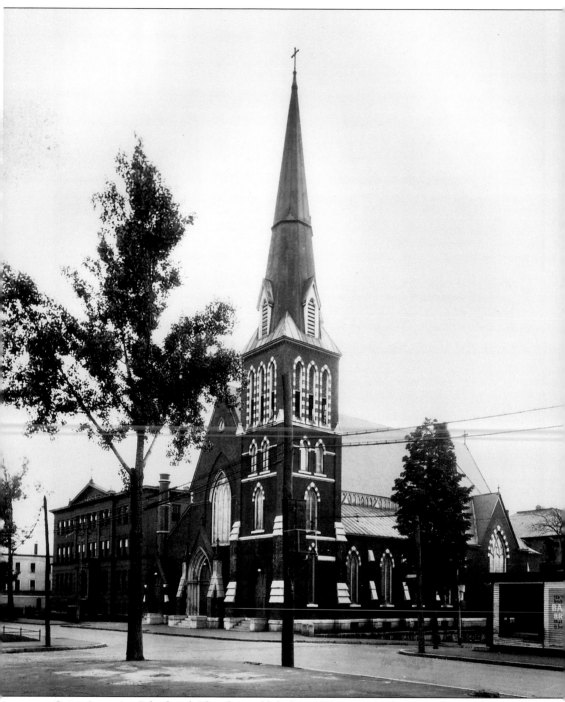

Saint Augustine School and Church, established in 1871, was the first French-Canadian parish in Manchester. Photograph by Ulric Bourgeois, circa 1925. (MVHC)

no person or corporation shall employ any person between the ages of sixteen and twenty-one, who cannot read or speak the English language, unless such person can produce a certificate properly made out showing their attendance at some such evening school if the district in which they reside maintains such an institution, or that he or she has been excused from attending such school for some good and satisfactory reason."

The recession of 1921–23 marked the beginning of a permanent economic decline for the New England textile industry; this, in turn, signaled a marked change in the Franco-American community. In 1922, a 20 percent wage reduction accompanied by a work week increase from forty-eight to fifty-four hours resulted in a strike throughout New England. At this time, Franco-Americans accounted for over 40 percent of the Amoskeag workforce. Because of the large proportion of the Franco-American community involved in the strike, the economic and social

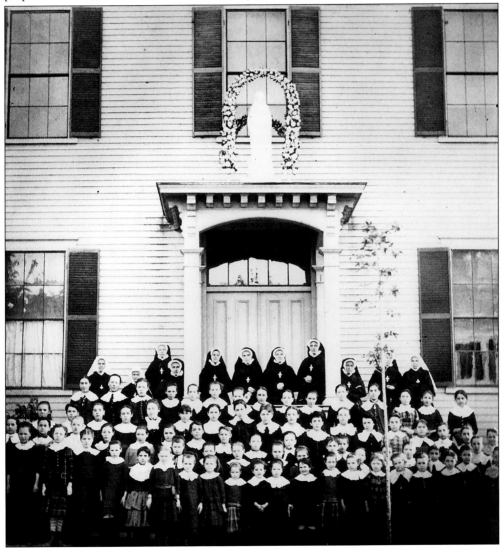

In 1881, the Sisters of Jesus Mary of Sillery, Québec, arrived in Manchester to assume the direction of the city's first Franco-American parochial school, the Convent of Jesus Mary for girls. It was situated in Saint Augustine parish. Photograph by Langley, circa 1890. (MVHC)

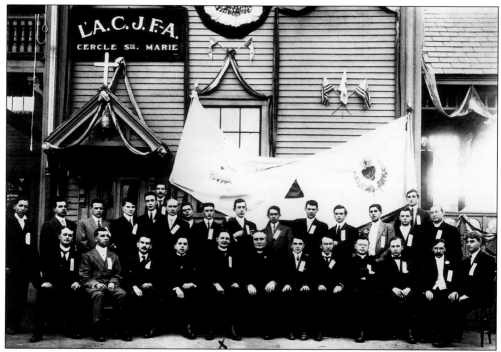

Members of L'Association Catholique de la Jeunesse Franco-Américaine, a Catholic youth group with affiliations in Québec and in France, gathered in Manchester for a convention in 1910. Photographer unknown, circa 1910. (MVHC)

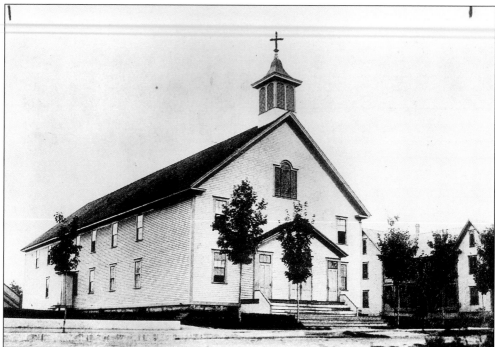

The first Sainte-Marie Church building, which was constructed in 1880, burned in 1890. Photographer unknown, circa 1885. (MVHC)

effects of the nine-month strike on the Franco-Americans were staggering. The commercial life of the city was disrupted, and dozens of small businesses went bankrupt against a backdrop of general economic hardship.

In late November, union officials recommended that the strike be called off due to the extreme suffering endured by its members. Although workers returned to the mills, the strike left a bitter heritage of hate and distrust towards the Amoskeag Company. As a result of the strike, over 13 percent of the city's inhabitants are believed to have left in search of other employment. The deteriorating relationship between the Amoskeag Company and its employees, competition from the southern markets, obsolete machinery, and poor management marked the end of a century of operation for the textile mill.

The closing of many of New Hampshire's textile mills contributed to the fragmentation of Franco-American communities throughout the region. The population of "Le Petit Canada" in each town began to diminish as Franco-American workers sought new areas of employment and broke away from distinct and quite insular communities. With the closing of the mills, where French was frequently spoken, French workers were thrust into the English-speaking world and their language was used less frequently. With the loss of their language, assimilation became more rapid and "La Survivance" lost strength.

Québécois artist Ozias Leduc was commissioned in 1906 to embellish the interior of the new Sainte-Marie Church. Photograph by Laurier Durette, circa 1930. (MVHC)

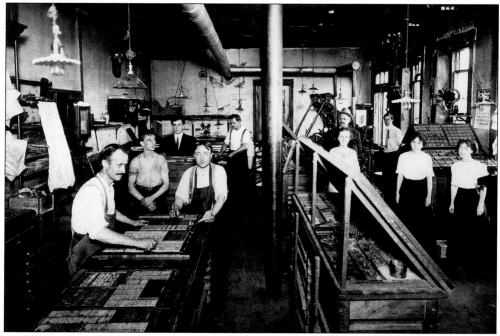

Inside the print shop of Manchester's French daily newspaper, L'Avenir national. The newspaper was founded in 1894 by Joseph E. Bernier and became a daily in 1901. Photographer unknown, circa 1911. (MVHC)

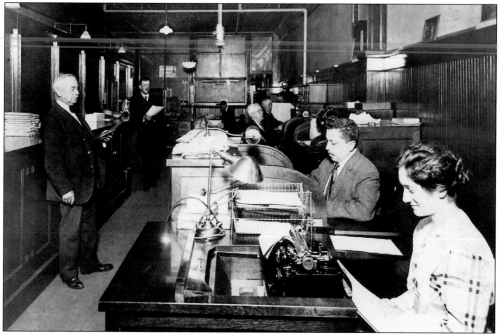

Founded in 1896, the Association Canado-Américaine was the first Franco-American Fraternal Life Insurance Society in the United States. The Society's headquarters, located in Manchester, serves members throughout New England and in the province of Québec. Photographer unknown, circa 1918. (MVHC)

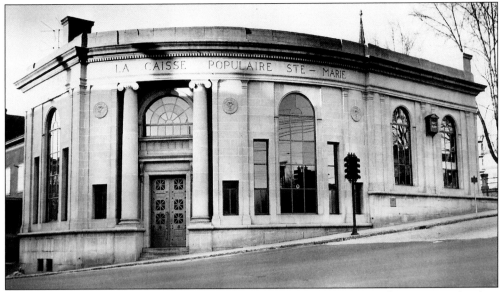

After two decades of prosperity, Saint Mary's Bank, the first credit union (la caisse populaire) in the United States, moved into new headquarters. All contracts for the design and construction of the new edifice were awarded to Franco-American firms and individuals. Photograph by P. Durette, circa 1930. (MVHC)

Every year on June 24, La Saint-Jean-Baptiste, feast day of the patron saint of Québécois and Franco-Americans, was celebrated with a Mass attended by the entire parish. Afterward, a festive parade was organized and led through the streets of "Le Petit Canada." This parade float commemorates cottage industries such as spinning and weaving, as well as French Canadian and Franco-American folk arts. Photograph by P. Durette, circa 1930. (MVHC)

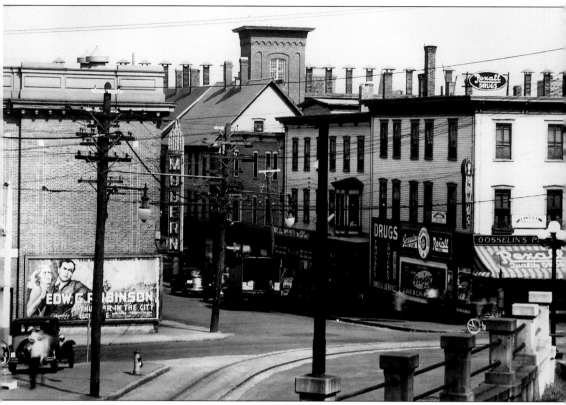

A view of the business district of "Le Petit Canada" on Manchester's West Side, during the Depression. Photographer unknown, circa 1936. (LC)

Although the French Canadians were the largest immigrant group in the Merrimack Valley, they were by no means the only group. The ethnic diversity of the state is cited in a report from the Census Bureau based on the 1910 census:

"The English and Celtic (including Irish, Scotch or Welsh) was the largest group among the 199,675 persons of foreign white stock in New Hampshire in 1910, who represented 46 per cent of the total white population of that state. The total foreign white stock whose mother tongue was English and Celtic (including Irish, Scotch or Welsh) numbered 85,637. This number represented about 20 per cent of the total white population of New Hampshire, which was 429,906. The French group numbered 82,448, or 19 per cent; the Polish, 5,264 or 1.2 percent; German, 4,980, or 1.2 per cent and Greek, 4,470, or 1 per cent. The number of persons in New Hampshire of foreign white stock reporting other principal mother tongues were: Swedish, 3,758; Italian, 3,003; Finnish, 1,859; Lithuanian and Lettish, 1,632; and Yiddish and Hebrew, 1,165."

Other immigrants to the Manchester area underwent similar experiences and transformations as they strove to make their way into the mainstream of American society. They have all contributed significantly and in different ways to the growth and prosperity of this great city on the banks of the Merrimack River.

Five

ULRIC BOURGEOIS FRANCO-AMERICAN PHOTOGRAPHER 1874–1963

Between 1850 and 1900, some 340,000 French Canadians abandoned the poor economic and political conditions in their native Province of Québec for the promise of a better way of life and a chance to more fully realize their ambitions in the industrial centers of New England. As the new century began, Québécois continued to relocate across the southern border, drawn away from small Canadian towns such as Waterloo, Magog, and Fulford by the attractions of prosperous American cities such as Manchester, New Hampshire. One of those who immigrated to this city shortly after the turn of the century was Ulric Bourgeois, a young French Canadian photographer from Waterloo. Fortunately, through Bourgeois' surviving work, the two entirely separate worlds experienced during a single lifetime by many early Franco-Americans continue to exist side by side today in a series of compelling images, which invite comparison and study.

When Bourgeois acquired his first camera, photography was less than half a century old. Already, however, distinct trends and technological advances were evident in the work of the myriad of American photographers active in the field. During the decade of the 1880s, George Eastman began marketing the gelatin dry plate; landscape photographer Carleton E. Watkins traveled to Wyoming to record the Mammoth Hot Springs; Eadweard Muybridge continued his photographic analysis of animal locomotion; and Jacob Riis documented the poverty among New York tenements. With the introduction of the one-hundred-exposure reloadable roll film Kodak camera in 1888, photography became more readily available to the general public.

In 1885, at the age of eleven, Bourgeois was given his first camera by Dr. Pagé, a local physician who had made the instrument in 1856, a mere seventeen years after the public

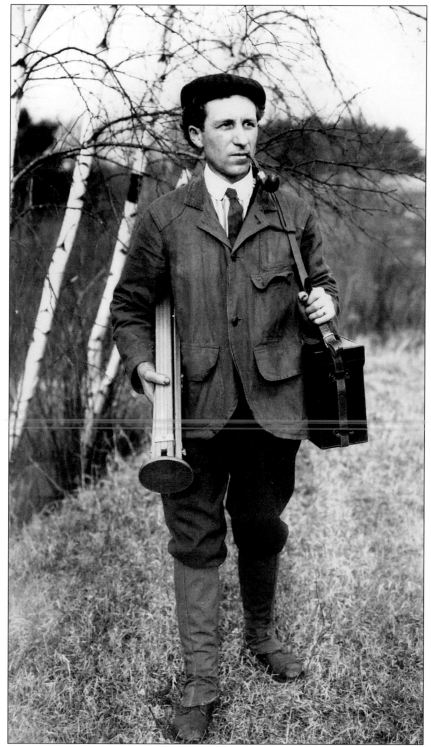

Manchester photographer Ulric Bourgeois, as he ventured forth with camera and tripod for a day of field work, circa 1913. Photographer unknown. (AB)

announcement of its invention by French artist and photographer Louis Daguerre. Like most cameras of that period, the lens of Pagé's early model lacked a shutter, requiring a steady and precise hand to remove and then recap the lens in order to make an "instantaneous" exposure without disturbing the tripod-mounted device. Bourgeois spent many hours experimenting with the outdated camera and with light-sensitive glass plates and chemistry, but initial attempts to make a photographic document of the Québec countryside failed. Eventually he overcame the limitations of the equipment and mastered some of the basic techniques of photography as it was then practiced, producing a gentle scene of ducks crossing the Yamaska River in the village of Fulford. This first successful image reflected his affinity for nature and foreshadowed his desire to record subject matter in a personally satisfying way. Encouraged, he pursued a more thorough working knowledge of this new medium. Several years later, an apprenticeship at Ethier Studios of Waterloo, Québec, provided Bourgeois with his first real opportunity to expand and refine his skills as a photographer.

Bourgeois learned how to make traditional studio portraits, created "trick" photographs—including one in which he plays checkers with himself—and gained a working knowledge of chemistry and its effect on the photographic process. It was during this period that Bourgeois' aesthetic philosophy about image making was shaped. He developed a preference for realism in portraiture, accomplished by photographing subjects in their own working or living environment rather than in the studio. This approach enabled him to capture more relaxed, and at times even spontaneous, expressions. Most professional portrait photographers were reluctant to leave the studio because of the great degree of control over lighting and equipment the studio setting afforded them. These photographers established standardized procedures in order to ensure a predictable, technically competent product. However, this highly controlled approach often resulted in unimaginative and stilted imagery. Bourgeois' determination to record people in their natural environment obliged him to transport cumbersome view cameras, support equipment, and fragile glass plate negatives to remote locations in order to achieve the authenticity of detail and expression he constantly sought in both his personal and his professional work.

Now in his early twenties, Bourgeois knew that his ambitions would not be realized in the dairy and agricultural milieu of rural Québec. Vacations spent visiting his brother Stanislas, who had previously settled in Manchester, gave Bourgeois the opportunity to assess the city's potential for a career there as a professional photographer. His bilingual ability would also enable him to conduct business with both the French and English-speaking people who made up a large segment of Manchester's ethnically diverse population.

Like so many other French Canadians who settled in Manchester, Bourgeois spent his first year here in the employment of the Amoskeag Manufacturing Company. The 1902 Manchester City Directory lists him as an inspector for the company. The next year, Varick's, which was located at 809 Elm Street and was then one of New England's largest department stores, hired Bourgeois as a photographer specializing in home portraiture and commercial photography. The firm boasted a huge inventory of photographic chemicals, supplies, a studio, a darkroom, and an extensive camera department. Here was an environment where the photographer's talent and vision could grow uninhibited by the more usual lack of equipment or demand for services.

It is important to note that the practice of photography during this period required a great deal of craftsmanship. Although manufactured dry plates and contact printing paper were readily available in a variety of sizes from firms such as the Eastman Kodak Company of Rochester, New York, photographers routinely prepared their own chemicals for the development process. Furthermore, precise exposure determination was not based on the use of the primitive light meters then available but on the working experience the photographer had with his particular light-sensitive materials and their response to development.

Bourgeois' passion for making pictures extended into the evening hours and weekends. A bicycle was his mode of transportation for moving his camera, tripod, and plate holders about the city to record events, architecture, streetscapes, and landscapes. Selected scenes would be

Members of the Fuller family of Manchester taken about 1921 in the familiar home environment that Bourgeois preferred to a formal studio setting. (HF)

published by Varick's as postcards, and Bourgeois often returned to the same location several times in order to obtain both different and better views of the same subject. Images during this period were made primarily on five-by-seven-inch glass plate negatives, although the eight-by-ten-inch size was sometimes utilized. Because the glass plates were cumbersome, only a dozen negatives could be exposed on each trip.

In the first decade of his career as a photographer in the United States, Bourgeois created two remarkable photographic series. The first, begun shortly after his arrival, was an extended portrait of Charles Lambert.

By the time Bourgeois met Lambert, the recluse was already well known in the community as the "Hermit of Mosquito Pond." A number of articles had already appeared in the local newspapers describing his simple life and rustic home located on 40 acres of land adjacent to Cohas Brook in southern Manchester. Lambert had been living his solitary lifestyle for half a century before Bourgeois made his first portrait of him, using his favorite glass plate camera, (a five-by-seven-inch Revolving Back Cycle Graphic, manufactured by the Folmer and Schwing Division of the Eastman Kodak Company).

Bicycling to the Mosquito Pond area (now known as Crystal Lake), Bourgeois brought fourteen glass plate holders to make as many as twenty-eight exposures of the man he had read about in the papers. Lambert's 1,200 head of sheep no longer existed for Bourgeois' camera to record, but the Hermit still conducted a vigorous survival routine worthy of documentation.

As far back as the 1880s, stories appeared detailing the Hermit's existence and interests. A journalist writing for the Manchester paper, the *Daily Mirror*, reported that Lambert had amassed quite a collection of Native American artifacts, which he had discovered on his property, including a flint hammerhead and gouges, arrowheads, and pieces of stone cooking utensils. During the summer months, Lambert could be found tending his garden, chopping wood, or patching up the shelter he had built for himself some time in the 1840s. He always had time to entertain his frequent visitors with old stories about his lumbering days with Hiram Brown, who became Manchester's first mayor in 1846. Now almost eighty years old, the Hermit became an inexhaustible subject for Bourgeois' camera: nearly two hundred negatives were made during a dozen years of friendship, thus creating an extended portrait of unprecedented scope.

Bourgeois was probably attracted to the Hermit and his lifestyle for a number of reasons. Like the photographer, Lambert was an immigrant to this country, having come from the county of Lincolnshire in England, a region well known for its sheep. At an early age, Lambert developed a strong interest in nature and the mysteries it held, which motivated him to explore the potential of roots, herbs, and other plants as ingredients in medical applications. Drawn by his curiosity to other parts of England and Europe, Lambert left a family of thirteen siblings behind in search of the plants that chemists and apothecaries valued. It was during this period that the lure of America took hold. Upon arriving in the United States, he visited Pennsylvania, New Jersey, and New York, before settling on the outskirts of Manchester some time in the 1840s.

A failed attempt at mastering law and an unrequited love appear to have led Charles Lambert to choose isolation. Over the years, he found solace in writing poetry, reading, maintaining a garden, and tending sheep. His vegetarian diet, which included peas, squash, corn, and other vegetables cultivated in the garden, enabled him to be relatively self-sufficient. His sober approach to living did not allow for the consumption of coffee, tea, alcohol, or the use of tobacco. Gathered herbs, surplus produce, and an occasional trip into town to sell animal pelts provided Lambert with whatever luxuries were necessary to maintain his reclusive lifestyle in the nineteenth century.

By photographing Lambert in his spare time, Bourgeois was able to return on weekends to the more simple life he had once enjoyed as a child in rural Québec. He made these images without concern for satisfying anyone but himself. Over the years Bourgeois developed a cinematic-like narrative approach to the telling of the Hermit's story in photographs. Virtually every aspect of Lambert's existence from season to season was documented in a style that belied the presence of a large tripod-mounted camera and an operator maneuvering glass plates in order to capture the moment.

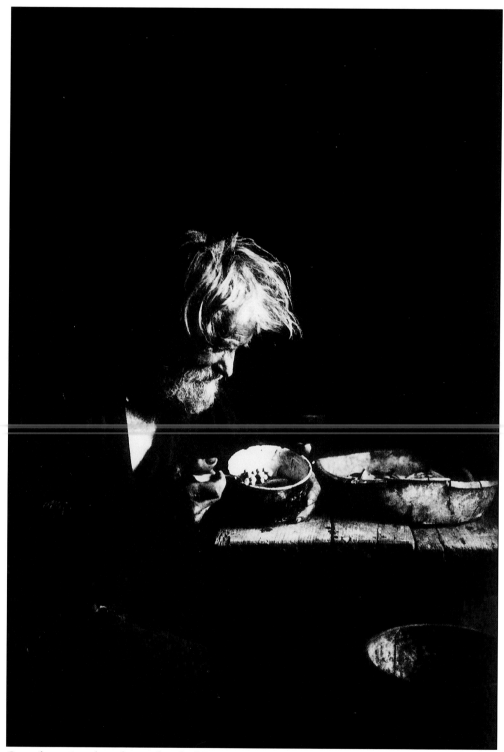

One of a series of nearly two hundred Bourgeois images that document the life and appearance of Charles Lambert, the eccentric Manchester recluse, from 1902 to 1912. (AB)

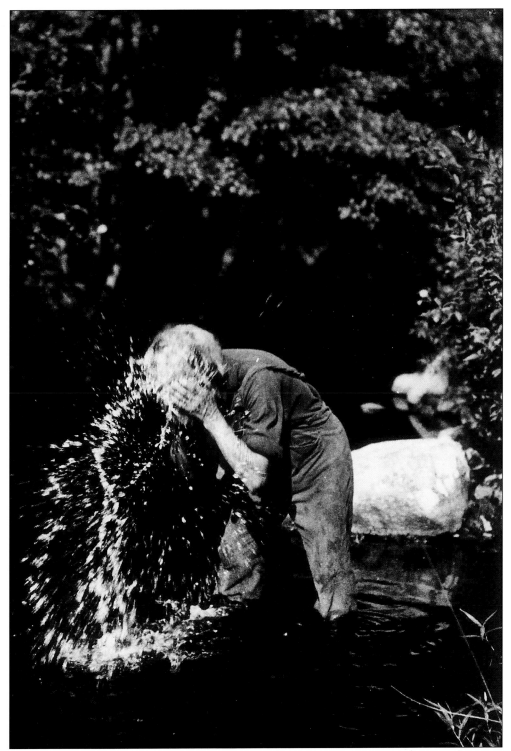

By the time of Lambert's death in 1914, Bourgeois had devoted much of his spare time over the course of a decade to recording the Hermit's lifestyle for posterity. (AB)

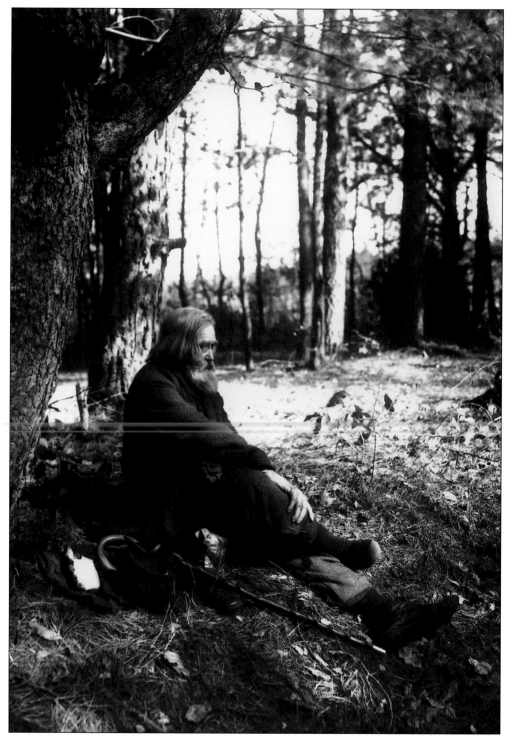

This portrait, taken circa 1913, was possibly the last one Bourgeois made of Charles Lambert. Although the Hermit has aged considerably, he still possesses the dignity that Bourgeois had so lovingly elicited from his subject in previous studies. (AC)

One winter, Bourgeois' affection and concern for Lambert prompted him to give the Hermit a new stove and a mattress with which to line his wooden bunk. The wood stove was met with enthusiasm, but the mattress found its final resting place outside leaning up against the cabin wall.

In the winter of 1912, the Hermit, suffering from pneumonia, collapsed in the snow. He was taken to Sacred Heart Hospital in Manchester and upon his recovery was moved to the House of St. Johns for elderly men. After almost seventy years in the woods, the Hermit did not adapt well to his new living conditions and decided to return to Crystal Lake without permission. He was eventually found and convinced to come back "for his own good" where the Sisters of Mercy could look after him properly.

Perhaps the last photographic collaboration between the Hermit and Bourgeois was a portrait made of Lambert during a visit back to the woods shortly before his death. Sitting in profile, he is dressed in a heavy overcoat and is now wearing glasses. It is evident in this image that while the Hermit has aged considerably, he still possesses the dignity that Bourgeois had so lovingly elicited from his subject in previous studies.

Lambert died at the age of ninety-one in the fall of 1914. His will designated that all his property be left to benefit and support St. Patrick's Orphanage in Manchester. Today, the cabin is gone and none of the Hermit's poetry, Native American artifacts, or other possessions survive. But there remain, of course, Bourgeois' portraits of this unique man to remind us of the power of photography to inform and move us.

Bourgeois' second artistic series deals with rural farm life in southern Québec. Return visits to relatives in Fulford and Valcourt d'Ely gave Bourgeois the chance to document the daily activities of both his wife's farming family and of his own father, who served the community of Fulford as blacksmith and "jack of all trades."

Revealed in these images, which he began making in 1908, is much of the shared experience common to French Canadians prior to their emigration to New England's mill towns. Central to the theme of this photographic study is the family and its inherent role in an agricultural milieu. The whole family participated in the farm chores necessary for their survival.

Bourgeois' wife and children are also captured in the process of enjoying themselves and the company of their relatives. They play checkers, laugh, tease, and occasionally pose unselfconsciously for group portraits. Although most of the images have a relaxed quality about them, they are all carefully composed. The comfort his subjects display in these photographs reflects Bourgeois' genuine affection for people and his ability to put them at ease in front of the camera.

Like the Hermit images, this body of work was created with the five-by-seven-inch folding camera which required the use of a tripod and the deliberate operation inherent to view camera work; yet so many of the images appear to be of such a candid and spontaneous nature that the viewer might easily conclude that they were made with a small, easily concealable hand camera. These artistic and technically accomplished images represent the most complete photographic record of rural life in Québec known to exist.

Bourgeois' Québec images are not dissimilar to those of another noted turn-of-the-century photographer, Chansonetta Stanley Emmons, who recorded gentle scenes of domestic life primarily in rural Maine but also in Massachusetts, Vermont, Connecticut, and New Hampshire. Like Bourgeois, she used the popular five-by-seven-inch view camera format for much of her picture making.

Bourgeois became a mature and successful craftsman and artist, remaining with Varick's for three decades. Photographic advertisements for the firm provided modeling opportunities for his young children—Irene, Antoinette, Lucienne, and Albert. He often incorporated humor into these images, just as he did with the private family photographs. Friends and relatives gathered together in the backyard found themselves the willing subjects for the photographer's inviting camera. The photograph on the following page, of a pet rooster towing a wagon with the photographer's daughter aboard, illustrates Bourgeois' romantic approach to the visualization of childhood innocence.

The winnowing operation, Valcourt d'Ely, Québec, circa 1908. (AB)

In contrast to such work, his services were available to, and utilized by, the Manchester Police Department for the documentation of sometimes gruesome accidents and deaths. Returning home late in the evening after preparing urgently needed photographic evidence, Bourgeois would be withdrawn and unable to eat. Perhaps this explains why Bourgeois was not motivated to record the people or operation of the sprawling Amoskeag Company complex—unlike his contemporary, the great social documentary photographer, Lewis Hine. Hine's photographic record of childhood, consumed by the industrial experience of early twentieth-century America, paints a dark and somber picture of children living in a world completely different from that of the children captured in a Bourgeois image.

Ulric Bourgeois was not a stranger to the Amoskeag Mills, however. His reputation as a professional photographic authority was widespread in the community, and as such, he was invited to share his expertise with the Company's Camera Club members on a number of occasions. The *Amoskeag Bulletin* reported in the March 1, 1915 edition:

"On Tuesday evening, Feb. 16, a demonstration in printing and developing of prints and films took place in Textile Hall. Ulric Bourgeois, of the John B. Varick Co., conducted the evening's instruction which all present thought the best so far held. About three dozen prints were made

from different negatives submitted using Velox and Azo papers. Instructions in developing roll films completed the evening's entertainment."

Membership in professional associations helped the photographer keep up with the latest technical advancements of the medium. Bourgeois was adamant about superior print quality and refused to imprint his name on an image unless it met his strict standards of perfection. He experimented with the cyanotype process on fabric, ultimately creating a variety of Hermit images on squares of cloth that were assembled into a large quilt by his wife. He would sometimes race down to the studio in the middle of the night, after waking with the solution to a photographic problem he had been struggling with, eager to confirm his theory. His creative ambitions were never limited to merely fulfilling the professional demands placed upon him in his daily work. Throughout most of his career, Bourgeois was one of Manchester's leading photographers, if not the leading photographer. The aesthetic and technical excellence of his images made him the first choice for the community's photographic needs. Varick's well-equipped studio and darkroom enabled Bourgeois to accept and solve most photographic problems that arose.

In the early 1930s he left Varick's and established his own business specializing in home portraits and commercial photography. His studio was originally located at 823 Elm Street, and he later moved it across the street to 864 Elm Street. A week's work for Bourgeois might include diverse subjects: streetscapes, aerial views, and buildings and their interiors; environmental portraits of politicians, clergymen, businessmen, families, and individuals; and special events such as parades, dedications, and weddings.

Dick the rooster and passenger Lucienne Bourgeois, circa 1907. (AB)

Bourgeois retired in 1950, having passionately devoted sixty-five years to the medium of photography. In that time he managed to record a significant portion of the visual history of the Franco-American community, including its origins in the agricultural lifestyle of Québec. Bourgeois had the distinction of having been the single eyewitness who was capable of making such a comprehensive photographic document of these events. He may not necessarily have been conscious of the story which these individual images tell when viewed as a coherent body of work, but his decision to record these moments indicates a singular sensitivity and understanding of the value of the black-and-white photograph as the most accurate and permanent method of visual documentation. Through Bourgeois' eyes and heart, we are still able to glimpse unique aspects of early twentieth-century life in Québec and the United States that might otherwise be forgotten today.

Bourgeois' artistic craftsmanship was not limited strictly to photography. After his retirement, he devoted his creative energies to a series of skillfully executed hardwood carvings, some based on his own photographic images. These bas-relief carvings represent a formidable amount of effort, some measuring as large as 4 feet in width. He remained active until his death in 1963.

Bourgeois' earliest surviving photographic image—the ducks crossing the Yamaska River—remains permanently affixed to the wooden case that protects his first camera, which he donated to the collection of the Manchester Historic Association. Fortunately, Bourgeois' daughter Antoinette recognized the significance of her father's personal work and preserved it so that his photographic legacy could be shared and appreciated by the audience it so deserves.

Bourgeois captures a moment of joy, as family member Laura Labonté entertains the photographer's son, Albert Bourgeois, circa 1912. (AB)

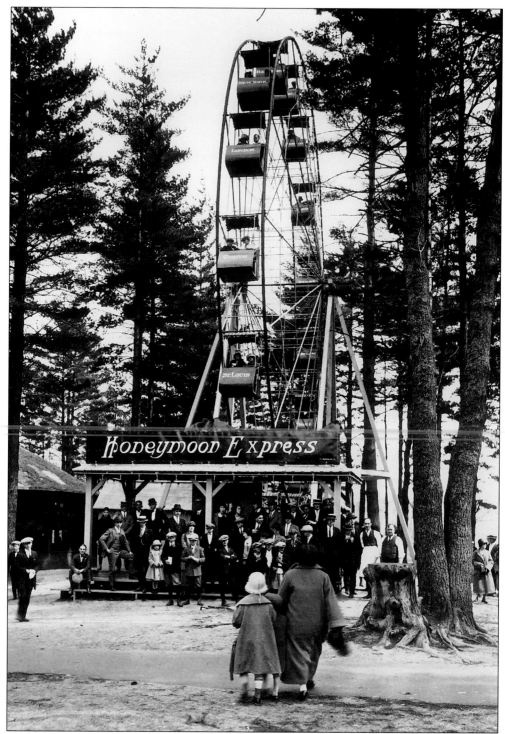

The ferris wheel at Pine Island Park, Manchester, circa 1925. (PSCNH)

Six

CONCLUSION

The Amoskeag complex survived intact for a third of a century after the property was acquired in the fall of 1936 at a cost of $5,000,000 by community business leaders attempting to save Manchester from the clutches of almost complete unemployment. Earlier that year, a plan submitted by Frederic C. Dumaine, treasurer of the Amoskeag Manufacturing Company, suggested that the mills could be reopened and successfully operated if conditions specified by the management could be agreed upon. However, approximately $2,500,000 in unanticipated damages caused by the flood of March 19 and a reduction in working capital of over $2,300,000 resulted in the withdrawal of the plan on June 10. A report by Special Master Arthur Black, released to the public on July 9, stated the the following:

"In my judgment reorganization is impossible. That being so, I believe it is kindest to all concerned to say so at once. I therefore recommend that liquidation be started at once, and that all salaries now being paid, or expenses incurred on the chance of reopening, be stopped at once. There should be no further expense, except for the preservation of the property."

Arthur Black chose William Parker Straw, Frederic C. Dumaine, and Joseph P. Carney as liquidating trustees following Federal Judge George C. Sweeney's order of liquidation. The mill buildings, machinery, housing, and remaining real estate were appraised at nearly $5,000,000. Because the company image was so strongly tied to the identity of the city, Arthur E. Moreau, Frank P. Carpenter, Harry L. Davis, John R. McLane, and others stepped in to rescue the mill yard from the auction block and possible subsequent demolition. Under their direction, Amoskeag Industries was incorporated on October 13, 1936, with the hope of attracting new, diversified manufacturing businesses to occupy the seventy-five buildings on both sides of the Merrimack River. It is ironic that after 105 years of operation, Amoskeag ended as it began: a real estate-development corporation. Within twelve years, Amoskeag Industries attracted 120 firms—employing 12,500 workers—and succeeded in preventing the dispersion of much of Manchester's labor force which would have occurred during the dark years of the Depression.

By the late 1960s, the mill yard, home for about eighty enterprises, came under close scrutiny because of its importance to Manchester's industrial base as well as its historical significance as the largest textile manufacturer in the world. In 1968, photographer Randolph Langenbach, under the direction of the Smithsonian Institution and the National Park Service Historic

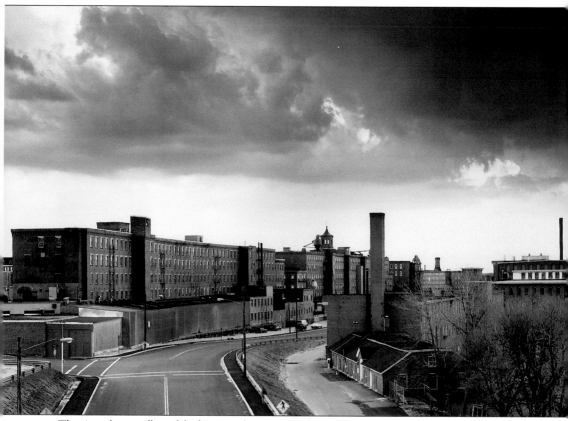

The Amoskeag mill yard looking south as viewed from the old Notre Dame Bridge. Photograph by the author, 1981.

Buildings Survey, documented the giant Amoskeag plant in order to create a permanent record of the facility. The mill yard was at a crossroads in terms of its future. It was not the only example of a completely integrated urban space on a grand scale in the United States, but its role as the community's industrial base placed major demands on the mill yard itself, suggesting that radical measures were necessary. These measures included the razing of some of the buildings, including a large portion of the structures that created the wall of red brick along the riverfront, as well as filling in the canals and paving them over to provide additional parking.

A 1961 report issued to the Manchester Housing Authority by Arthur D. Little Inc. stated that, "even with extensive improvements and upgrading, the mill yard will never be an asset from an aesthetic point of view."

The late 1960s witnessed the implementation of demolition and redevelopment plans for urban communities across the country, and Manchester was no exception. In order to make the mill yard area more viable economically as well as more easily accessible by trucks and automobiles, the city embarked upon the nation's first federally funded industrial rehabilitation project at a cost of $30,000,000 in public funds, including $8,000,000 in city money. The urban renewal project saw the elimination of many of the buildings which precisely described Amoskeag's unique urban environment. Certainly the loss of some of these buildings in the mill yard was necessary in order to enhance its competitiveness economically, but what was also lost was the intimate visual and emotional associations that the people of Manchester had with this architectural icon of the Industrial Revolution.

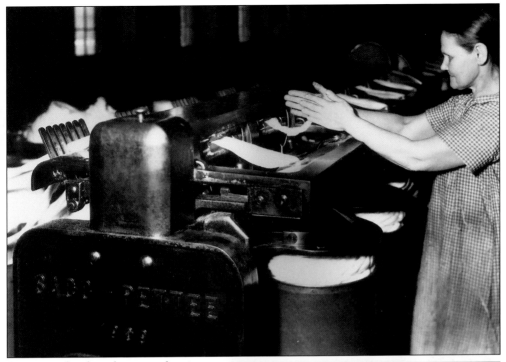

Repairing a break in sliver on a drawing frame: four to eight strands of sliver are passed through the four pairs of drawing rollers of this machine (each roller revolving faster than the preceding one) to form one thinner and more even strand of sliver. Photograph by Lewis Hine, 1936. (NA)

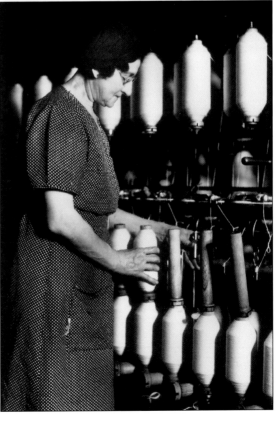

Tending a fly frame (doffing). This machine, like the intermediate, speeder, and jack frames, continues the process of drawing out the roving and making it more compact. Photograph by Lewis Hine, 1936. (NA)

While manufacturing still continues in the mill yard today, new and innovative tenants have also taken up residence in renovated facilities. The downtown campus of the University of New Hampshire at Manchester is located on the first, second, and third floors of 400 Commercial Street in the heart of the mill yard. Elsewhere can be found WMUR-TV Channel 9, Rounds Custom Photo Lab, and Alpha-Bits Learning Center, a children's day care center.

In the late 1980s, architects Christopher Eseman and Douglas McCallum prepared a futuristic plan with the help of the National Endowment for the Arts that would transform the mill yard into an urban neighborhood. Industrial parks around the city would absorb the remaining manufacturing area still located in the mill yard so that retail shops, professional offices, grocery stores, art galleries, restaurants, recreational facilities, and housing would integrate the mill yard into the grid of the city. The fifty-year plan would also include a pedestrian walkway spanning Canal Street, apartment towers located on the banks of the Merrimack River, a skating rink, and a pedestrian bridge connecting the area with the West Side.

There are many cultural institutions located in Manchester, including the Currier Gallery of Art, the New Hampshire Institute of Art, the New Hampshire Symphony Orchestra, the New Hampshire Performing Arts Center at the Palace Theater, and, of course, the Manchester Historic Association. Besides the University of New Hampshire at Manchester, other institutions of higher education in the Manchester area include Hesser, New Hampshire, New Hampshire Vocational Technical, Notre Dame, and Saint Anselm Colleges, which provide Manchester residents with a variety of educational opportunities and choices.

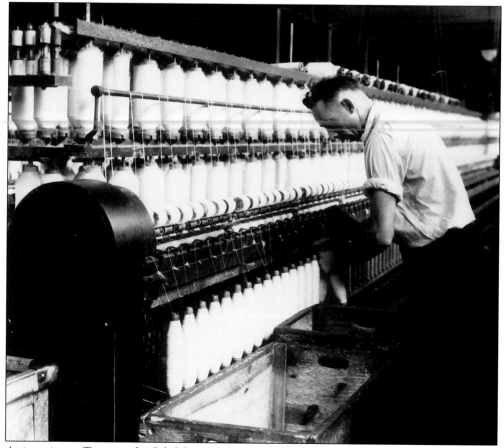

A ring spinner. Two strands of slightly twisted roving are transformed into one strand of tightly spun yarn by this machine. It also winds the yarn on bobbins. Photograph by Lewis Hine, 1936. (NA)

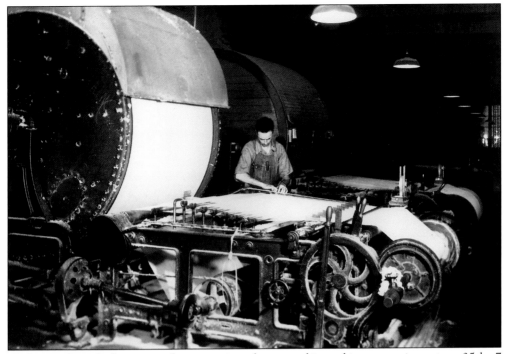

Slashers perform the last step in the preparation of a warp; this machine, occupying a space 35-by-7 feet, starches and dries the threads of the warp. Photograph by Lewis Hine, 1936. (NA)

In keeping with its history, the Manchester area continues to attract many newcomers, including new immigrants. The ranks of the original immigrants who came to work in the mills have been swelled by recent arrivals from around the world, among them families from Africa, Vietnam, and the Philippines. The Latin-American Center of Manchester serves the needs of the community's more than 5,000 Hispanic citizens.

Institutions such as the Association Canado-Américaine with its Franco-American Centre still thrive and continue to support the infrastructure of the Franco-American community. Although on a smaller scale, the Feast of Saint John the Baptist (La Saint-Jean Baptiste) is still celebrated, and the Franco-American community maintains close ties with Québec.

A significant number of Manchester-area residents continue to feel strongly enough about their ethnic heritage to maintain their mother tongue in the home. Individuals who once sought to distance themselves from their ethnic identity in order to avoid possible ridicule are now researching their history and demonstrating pride in their roots. On Manchester's West Side, one still hears French spoken frequently on the street or in local commercial establishments. For years, the *Union Leader*, New Hampshire's only statewide daily newspaper, acknowledged this presence by publishing a regular French-language column. Today, as one hundred years earlier, Franco-Americans continue to be the largest minority group in the community.

Since the nineteenth century, when 80 percent of the country's cotton production was based in New England, New Hampshire has remained near the top of the nation's industrial scale. However the state's economy, at one time heavily reliant on textiles and other soft goods such as shoes, now revolves around electronics and plastics. Today, thousands are employed in high-technology firms, which have in some instances found homes in the mill yards that once dominated the landscape and life of many of New Hampshire's cities and towns.

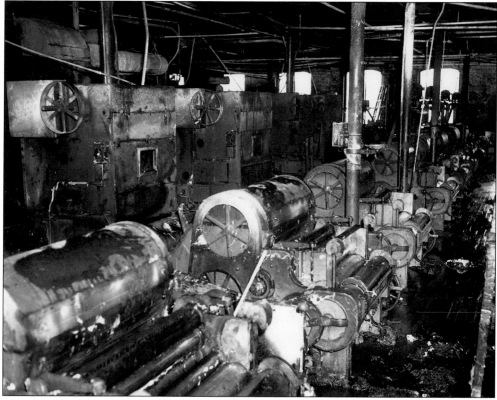

The aftermath of the 1936 flood. The first floor of Amoskeag Manufacturing Company buildings lining the river were completely under water during the flood. Photograph by Laurier Durrette, 1936. (GD)

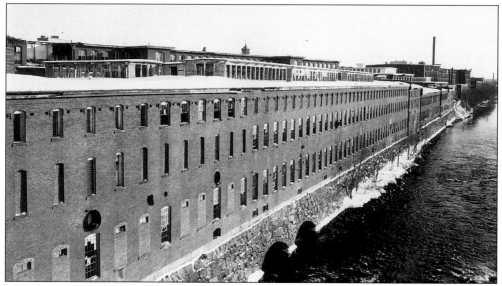

This perspective looking south shows the wall of red brick which lined the Merrimack River. The building in the foreground, which housed the Arms Textile complex, was demolished in 1976, largely for health reasons as it was contaminated with anthrax. Photograph by the author, 1969.

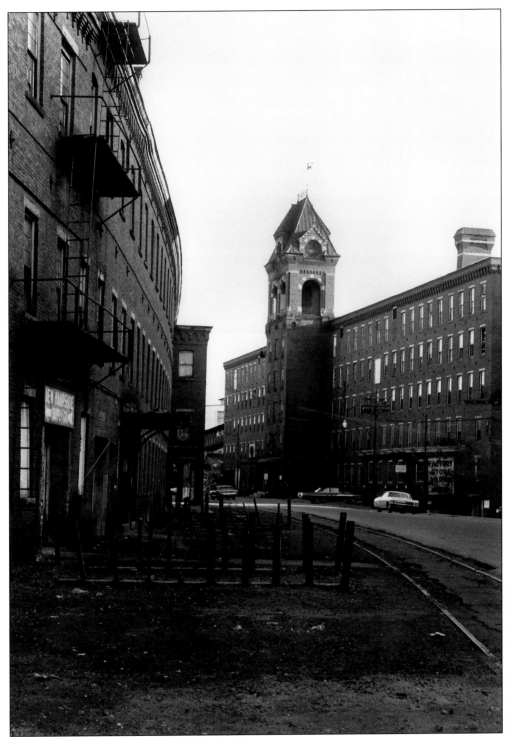

This view of the mill yard shows the close proximity of the buildings to each other. Eventually, some buildings were razed to create fire lanes for the large equipment developed to fight fires in high-rise buildings. Photograph by the author, 1969.

Demolition of one of the few gable roof buildings which survived into the twentieth century. Photograph by the author, circa 1969.

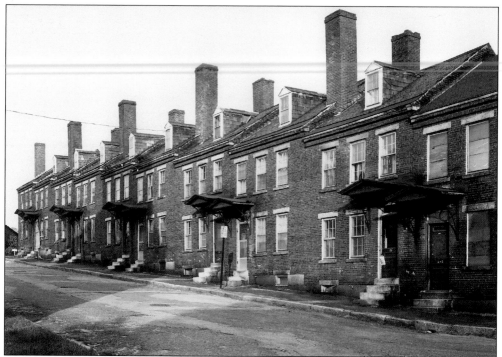

While a portion of the Amoskeag Company housing has been demolished in recent years, buildings that have survived have in some instances been refurbished and sold as modern condominiums, preserving a sense of history in the Manchester community. This example of row housing is reminiscent of similar structures found in and around Manchester, England. Photograph by the author, 1976.

An interior view of a stairwell in the Arms Textile complex. Although this building fell into disrepair and was eventually razed, other buildings with similar architectural characteristics have been refurbished for a variety of commercial, industrial, and educational uses. Photograph by the author, 1975.

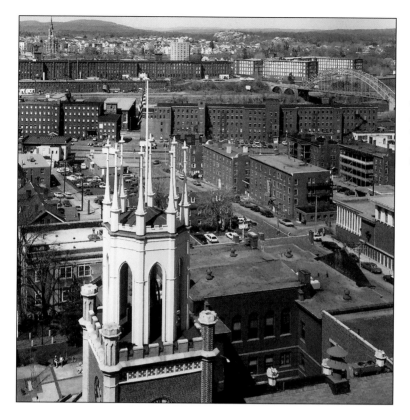

The bell tower of Manchester's City Hall dominates this perspective of the downtown area and of West Manchester, across the river. Photograph by the author, 1981.

Manchester remains the most populous city in the state and has become the banking center of New Hampshire. Although the downtown Victorian streetscape has changed dramatically in recent years through the addition of modern corporate office space erected by the major financial institutions, many fine examples of Victorian architecture, including elegant structures such as the Ash Street School, can still be found throughout the city.

The textile mills of the Merrimack Valley, seemingly invincible as the nineteenth century came to a close, symbolized different meanings to the communities they spawned as the industry sputtered to an end in the first half of the twentieth century. For some, the former textile laborers and their children, the memory of mill life is a bitter one, more easily forgotten now that much of the only physical remnants that remained—the brick factories—have been razed. Others who built lives, families, and careers out of the opportunities that existed during the heyday of the mills viewed the experience as a kind of salvation from a possibly worse fate, had they remained in their country of origin. No matter what role these workers played, overseer or doffer, they all contributed significantly to the vast success the industry came to know as part of the Industrial Revolution that forever changed the course of our daily lives.

Today, Manchester is much less vulnerable to economic vicissitudes since the financial base of the community is far more diversified. The Amoskeag Mill yard will most certainly pass into the twenty-first century, adapted for new uses and surviving as a testament to the architectural integrity with which it was first constructed. Fine examples of the products the mills produced, such as the Amoskeag Steam Fire Engines, are preserved in museums throughout North America, a witness to New Hampshire innovation and craftsmanship, which continue.

BIBLIOGRAPHY

Amoskeag Bulletin, 1:6 (1913)–9:11 (1921).

Amoskeag Steam Fire Engines. Philadelphia: Edward Stern & Co., 1895. Exact facsimile reprinted by Manchester Historic Association, 1974.

Anctil, Pierre. "From Québec to New England." *Ovo Magazine* (Montréal, Québec), vol. 12, no. 46 (1982).

Bacon, George F. *Manchester and its Leading Business Men, Embracing Also Those of Goffstown.* Boston: Mercantile Publishing Company, 1891.

Blood, Grace Holbrook. *Manchester on the Merrimack.* Manchester, New Hampshire: Lew A. Cummings, Co., 1948.

Brault, Gerard J. *The French-Canadian Heritage in New England.* Hanover, New Hampshire: University Press of New England, 1986.

Browne, George Waldo. *The Amoskeag Manufacturing Company of Manchester, New Hampshire: A History.* Manchester, New Hampshire: Amoskeag Manufacturing Company, 1915.

Creamer, Daniel, and Charles W. Coulter. *Labor and the Shut-Down of the Amoskeag Textile Mills.* Philadelphia: Work Projects Administration, 1939.

Dunwell, Steve. *The Run of the Mill.* Boston: David R. Godine, Publisher, 1978.

Haraven, Tamara K., and Randolph Langenbach. *Amoskeag: Life and Work in an American Factory City.* New York: Pantheon Books, 1978.

Hopkins, Mary Alden. "New England Mill Slaves." *Good Housekeeping* (September 1913).

Jager, Ronald, and Grace Jager. *New Hampshire: An Illustrated History of the Granite State.* Woodland Hills, California: Windsor Publications Inc., 1983.

Langenbach, Randolph. "An Epic in Urban Design." *Harvard Alumni Bulletin* (April 3, 1968).

Manchester, the Queen City of New Hampshire. Manchester, New Hampshire: Mirror Press, 1903.

Newhall, Beaumont. *The Daguerreotype in America.* New York: Dover Publications Inc., 1976.

Newhall, Beaumont. *The History of Photography.* Boston: Little, Brown and Company, 1982.

Perreault, Robert, B. "The Franco-Americans." *Ovo Magazine* (Montréal, Québec), vol. 12, no. 46 (1982).

Pillsbury, Hobart. *New Hampshire: Resources, Attractions and Its People.* Vol. III. New York: The Lewis Historical Publishing Company, 1927.

Rayner, Paul. "Lewis Wickes Hine: Progressive Photographer." *Ovo Magazine* (Montréal, Québec) 26, (1977).

Rosenblum, Naomi. *A World History of Photography.* New York: Abbeville Press, 1984.

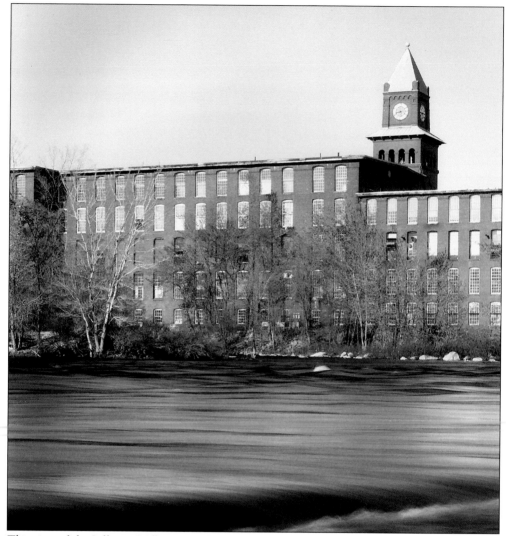

This view of the Jefferson Mill, as seen from the west bank of the Merrimack River, testifies to the constancy of the mills. Photograph by the author, 1988.

Samson, Gary. "Ulric Bourgeois (1874–1963): Franco-American Photographer." *Historical New Hampshire*, vol. 46, no. 3, (fall 1991). New Hampshire Historical Society, Concord, New Hampshire.

Thoreau, Henry D. *A Week on the Concord and Merrimack Rivers.* Carl F. Hovde, editor. Princeton, New Jersey: Princeton University Press, 1980.

The Union Leader, 125th Anniversary Edition, Manchester, New Hampshire, (March 31, 1988).

Valade, Edmond J. *The Amoskeag Strike of 1922.* Durham, New Hampshire: University of New Hampshire, Unpublished Master's Thesis, 1964.

Vicero, Ralph. *Immigration of French Canadians to New England, 1840–1900. A Geographical Analysis.* Ann Arbor, Michigan: University Microfilms Inc., 1968.

INDEX

Académie Saint-Augustin for boys, under the direction of the Brothers of the Sacred Heart, founded in 1889. Photographer unknown, circa 1905. (MVHC)